FROM THE WEST

Chicano Narrative Photography

FROM THE WEST

Chicano Narrative Photography

Curated by
Chon A. Noriega

Sponsored by
The Lila Wallace-Reader's Digest Fund

Additional Support Provided by
The Lannan Foundation
and the National Endowment for the Arts

THE MEXICAN MUSEUM
SAN FRANCISCO

FROM THE WEST:
Chicano Narrative Photography

December 9, 1995 through March 3, 1996

Copyright © 1995 by The Mexican Museum

Works of art copyright © by the artists

ISBN 1-880508-04-4

Cataloging-in-Publication Data is available.

FROM THE WEST: Chicano Narrative Photography is the fourth of four traveling exhibitions in a series entitled *Redefining the Aesthetic: Toward a New Vision of American Culture*, sponsored by a generous grant from the Lila Wallace-Reader's Digest Fund. *FROM THE WEST* was also sponsored in part by the Lannan Foundation and the National Endowment for the Arts.

Front Cover: Miguel Gandert, *Laura Aguilera, Talpa, New Mexico,* photograph, 1995.

Catalogue Design by Shore Design

Edited by David Featherstone

Printed by Singer Printing

Distributed by University of Washington Press
P.O. Box 50096
Seattle, Washington 98145

The Mexican Museum
Fort Mason Center, Building D
Laguna and Marina Blvd.
San Francisco, California 94123
415-441-0445

CONTENTS

ACKNOWLEDGMENTS

Marie Acosta-Colón
EXECUTIVE DIRECTOR

THE MEXICAN MUSEUM is proud to present *From the West: Chicano Narrative Photography*, the fourth in a series of four traveling exhibitions examining issues in Chicano art. The series, entitled *Redefining the Aesthetic: Toward a New Vision of American Culture*, is sponsored by a generous grant from the Lila Wallace-Reader's Digest Fund. The Museum also wishes to thank the supporters of the four individual exhibitions: The National Endowment for the Arts, the Rockefeller Foundation, the Lannan Foundation, AT&T, the California Arts Council, the Andy Warhol Foundation for the Visual Arts, and the Gap Foundation. *From the West* will travel nationwide for the next two and a half years.

Special thanks to guest curator and principal essayist Dr. Chon A. Noriega, who selected and commissioned the six photographers to create work that takes into account the historical, artistic and cultural context of Mexican Americans and the meaning of *their* West.

I would also like to thank Jennifer A. González for her perceptive and insightful essay, Ron Shore of Shore Design for vision and artistry in designing and producing this catalogue, David Featherstone for masterful editing of the catalogue text, and Paul Felder for his skill in reproducing the artwork.

A special "thank you" to the Museum's Director of Exhibitions and Education, Dr. Terry Shtob, who accomplished the challenging task of coordinating the exhibit and overseeing the catalogue's production with clear vision and keen insight. Registrar Julie Franklin was exemplary in arranging for the transit of the works and their photography. Curatorial Assistant Denise Morilla-Lyons and Elizabeth Escamilla displayed patience and diligence in pursuing additional venues for this exhibition and attending to many other important details. A final appreciation goes to the Museum's former Associate Development Director Amy Schoenborn for her persistence in obtaining additional support for this project.

MANY WESTS

Chon A. Noriega

*The West's development was not simple heroic progress:
American history contains many Wests, all more or less "invented."*

Eric Foner and Jon Wiener, 1991[1]

THERE ARE MANY WESTS, or so we are being told by a new breed of Western historians. Gone is the old view of the West as the frontier of an expanding civilization, a wilderness to be fought over and tamed so that settlement could advance. Today, the West is a *place* and not a *process*, and its significance in American culture lies in the conflicting meanings given to that place.[2] Indeed, there is a different West for every group; and yet, despite the proliferation of diverse and complex historical accounts of these many Wests, their impact remains largely confined to the academy. The old view of the West still holds sway over the national imagination, from popular entertainment to political rhetoric.[3] These other Wests, it would seem, are outgunned by socioeconomic forces in need of a simple view of the past and an even simpler promise of unbridled opportunities stretching into the future.

This exhibition examines one of these many Wests — that of the Mexican, Mexican American, and Chicano populations — and its complex and ambiguous relationships with the other Wests, but especially the old, wild one of the Western. Focusing on narrative photography, *From the West: Chicano Narrative Photography* situates its examination within a larger argument about the Western as a uniquely American genre that spans the visual arts, literature, and popular culture, and that continues to inform our sense of national identity.

COWBOYS AND INDIANS

I don't know how much the Western film means to Europe; but to this country it means the very essence of national life....It is but a generation or so since virtually all this country was frontier. Consequently its spirit is bound up in American citizenship.
William S. Hart, 1916[4]

Before turning to the exhibition itself, I want to suggest another approach to the Western, in which the usual focus on space — the West — is understood as an instance of nation-state formation, rather than of individuals in search of freedom, property, and marriage on the frontier. In other words, I want to echo William S. Hart and reintroduce citizenship as the genre's central dilemma. But unlike Hart, I want to draw attention to how the very binary oppositions that he introduced into the Western — the loner cowboy and society, lawlessness and community, landscape and town — do not so much describe the geopolitical space of American citizenship as determine its key players.[5] Those who are left over — Mexican, Indian, Chinese, Black — are cast as an external threat even though they share the same space. They are there (physically), yet not there (rhetorically), an exclusion that has at times been written into law or government policy and has been contested in the name of the rights of citizenship.[6]

Calling attention to geopolitical space does more than place national boundaries within an historical perspective in which we acknowledge that the Southwest used to be the northern half of Mexico — although, in the scheme of things, that's not a bad place to end up. Rather, a geopolitical framework understands the time-and-space of the Western as the textual displacement or subordination of other histories. For the Mexican-descent population, this includes issues of language and translation, communal versus individualistic legal definitions of land ownership, and political representation — all of which, by the way, continue to be sites of struggle. Still, calling everyone within the West an American does not resolve the problem, since the underlying conflicts between groups and cultural systems continue long after a nation has set its borders and imagined itself as a limited, sovereign community.[7]

The problem with borders is that they are more or less invented or imagined, much like the communities they are designed to contain.[8] This is not to suggest that communities do not exist, but rather to note the way in which

Chon A. Noriega is an assistant professor in the UCLA Department of Film and Television. In 1993, he co-curated *Revelaciones/Revelations: Hispanic Art of Evanescence*, an exhibit of site-specific art at Cornell University.

borders manifest, as Etienne Balibar notes, "the contradiction between the pretension of the modern state to constitute a 'community' and the reality of different forms of exclusion."[9] This contradiction operates within national borders as well as across them. Consider all the "Mexicans" who populated the Southwest of the Western; by all rights these were Mexican Americans. Legally, Mexicans who remained north of the new border, imposed after the Mexican-American War (1846–1848), became U.S. citizens. But in social practice and popular culture, Mexican Americans continued to be referred to as "Mexicans" up until the Chicano Civil Rights Movement (1965–1975), and have been subject to various large-scale deportation programs since the so-called repatriation of the Depression. In the foundational fictions that secured the once-Mexican territories to the imagined community of the United States, the Mexican American functioned as what Blaine Lamb calls the *convenient villain* of the discourse on the Southwest, appearing as a necessary, though marginal character in newspapers, government documents, dime novels, popular songs, plays, and, later, silent films.[10]

Since the 1910s, however, with the exponential increase in Mexican migration that began then, we see a shift from the marginal to the *missing* Mexican American of the West. Travel writer Charles F. Lummis summed up this aversion in formal terms in his 1913 book on New Mexico, *The Land of Poco Tiempo*:

> The flat Mexican towns themselves are picturesque— for the ardent sun of the Southwest makes even an adobe beautiful when it can pick it out in violent antitheses of light and shade. Their people — ragged courtiers, unlettered diplomats — are fast losing their pictorial possibilities.[11]

Lummis's juxtaposition of noble Indians and ignoble Mexicans, as Enrique R. Lamadrid and others have pointed out, found a visual counterpart in the painters and photographers of his times, whose romantic images fueled the nascent industry of ethnic tourism.[12] The subsequent "ersatz mythology" of Indian and Spanish cultures provided, as Carey McWilliams wryly noted in 1946, "a much better, a less embarrassing, symbol of the past than the Mexican field worker or the ragamuffin pachuco of Los Angeles."[13] The same paradigm persists today, even in much of the revisionist literature and exhibitions on Western painting, photography, and cinema.[14]

With the closing of the frontier in 1890, as Richard Slotkin notes in *Gunfighter Nation*, the "West became a landscape known through, and completely identified with, the fictions created about it."[15] Subsequently, for Mexican Americans, the Hollywood Western provided the dominant fiction about their place or non-place in the national myth.

These stories situated Mexicans at the margins of the Western and made them a necessary and natural backdrop to the genre's ostensible conflict between the Individual and Society. As with a card trick, the viewer tries to catch the sleight-of-hand that reconciles one to the other by looking at the interplay between its acknowledged archetypal characters: the cowboy, the heroine, the villain, and the Indian. But therein lies the trick of the trick, the very essence of the Western: it has drawn our attention away from a wider field of social relations — the melange of races, cultures, languages, and social orders in the Old West — and focused it on the narrative machinations that rewrite endogamy as national epic.[16]

EXHIBITING THE WEST

The true point of view in the history of this nation is not the Atlantic coast, it is the Great West.
Frederick Jackson Turner, 1893[17]

The idea for *From the West* came about as a response to the oft-cited fact that the West has been a central element in the development of major American art forms — and vice versa. In the past decade, a number of exhibitions have examined this dynamic in great detail, most notably: *The West of the Imagination* (1986), *Myth of the West* (1990), *The West as America* (1991), *Discovered Lands, Invented Pasts: Transforming Visions of the American West* (1992), and *The Frontier in American Culture* (1994). Indeed, as an expression of national identity, the West continues to be a source of both popular and critical fascination. This is also seen in the recent plethora of books, documentary series, and, of course, in the resurrection of the Hollywood and television western. This popularity suggests not just an ongoing deep interest in the West, whatever the political orientation, but the development of an industry responsive to those interests.

But in all these texts, the focus continues to be on Euro-American artists and writers looking West, even in those books, exhibitions, and films that undertake an act of historical revisionism.[18] Whether intending to praise or attack the West, these texts nonetheless reaffirm it as a privileged way of looking. When Mexican American perspectives are included, it is often as an aside or addendum dealing with the contemporary period, which implies that these perspectives are a recent phenomenon that do not complicate the linear genealogy of the West.[19] In other words, these books and exhibitions are willing to concede the present moment to multiculturalism or racial diversity, as long as the past remains a pure vision of the Wild West, wherein white settlers and cowboys set about the epic task of nation-building on the Frontier. Some celebrate, others critique; but the genealogy remains the same.[20]

Understandably, marginalized groups often find very little difference between critical and celebratory examinations of hegemonic concepts. Both reaffirm a way of looking that excludes them, not just from the national culture, but as bearers of its gaze — that is, as those who get to look West. There are limits to the critique of the West insofar as it must be undertaken within the very national framework produced by the myth of the West. As Kevin Starr explains, "even those who wish to qualify Frederick Jackson Turner wind up agreeing with the most central point of his thesis: namely, that looking west, moving west, being in the West, building and creating from a western perspective, brings us close, very close, to the inner meaning of our national experience."[21] But this assumes that there is *one* western perspective from which to look and create, and that it leads to the *one* inner meaning for *our* national experience. If so, then looking West is always an act of incorporation that gives unity to an expanding American nation; or, as Jorge Castañeda argues, "Even where it began centuries ago, nation-building is by definition a perpetual chore, never laid to rest, never fully, finally achieved."[22] The problem arises when the idea of the West fails to take into account those who came *from* the West, those who did not build and create from a western perspective but were, rather, conquered and subordinated by that perspective. The idea of the West, then, exists in a double space, oscillating between imagined coherence and actual exclusion, such that the many Wests of revisionist historians must be forestalled or projected into a future that operates on fundamentally different terms.

Perhaps because of the continual deferral of the many Wests and the problematic aspects of integration into the prevailing national myth, Chicano artists and scholars have rarely worked from a Western perspective, a perspective that Starr claims "makes us all Turnerians."[23] If anything, Chicano histories can be seen as one of a number of anti-Western narratives, especially insofar as these histories are often told from dual and multiple perspectives that call into question the stable borders for a region.[24] Thus, if *American* historians are still Turnerians at heart, then these *other* histories reveal the limits of reforming or supplementing the Western paradigm and call out instead for a new one able to integrate the many Wests into a national history.[25]

So what has the notion of the West meant for Chicano artists in terms of ways of looking? Implicit in this question is another one about location: Where, or in what contexts, do Chicano artists belong? Needless to say, there is no simple or single answer unless one looks at the exhibition record of U.S. arts institutions.[26] *From the West: Chicano Narrative Photography* is the result of ongoing conversations about these issues with the six photographers included here: Robert C. Buitrón, Christina Fernandez,

Harry Gamboa, Jr., Miguel Gandert, Delilah Montoya, and Kathy Vargas. These artists — as Chicanos, as photographers, but especially as artists — often fall between the gaps of both mainstream and minority curatorial practices. In looking for ways to help close this gap, I found the photographers, themselves, provided the best precedents in their own curatorial and advocacy efforts. In 1994, for example, Buitrón and Vargas conducted historical research into Chicano photography, curating a survey spanning the years 1940 to 1993. What is of special interest, however, is that their selections were placed in the context of a broader Latino photography exhibition called *American Voices* and presented at Houston's Fotofest '94. This was no simple plea for inclusion. Vargas and Buitrón moved between ethnic, pan-ethnic, and national identifications (Chicano, Latino, American), rather than unquestioningly privileging one over the others; and they situated the exhibition at the biannual meeting of an advocacy and market-oriented professional group, rather than in a community-based *centro* or *galería*. What I want to draw attention to is not the curatorial strategy per se, since it should be but one of many, but the way in which it refused prescribed aesthetic and social boundaries for the photographs.

From the West follows upon similar impulses; but rather than offer another historical survey of Chicano photographers, this exhibition takes a thematic approach to the underlying questions of context. In considering the American West and its significance for their work, these photographers have, in effect, provided a series of meditations on three concurrent histories that have unfolded since the mid-nineteenth century: Mexican American or Chicano history, the history of photography, and the military conquest and cultural construction of the West as part of the United States. *From the West* provides an opportunity to explore how these three histories have related to each other in complex and contradictory ways over the past 150 years. As the title implies, there is more involved than a simple oppositional politics of tit-for-tat. To look *from* the West returns the westward gaze without the false comfort of standing in a mythical space outside of History (whether it be the West or Aztlán). For this reason, the works in this exhibition express a certain ambivalence about their location, mixing together references from the three essential terms — American West, Chicano, and photography — around issues of narrative. What is at stake here is a question about historiography: How does one critique a dominant culture *and* express an alternative perspective if the two are intimately implicated in each other's very existence? Rather than accept the camera as the producer of objective documents, these photographers, even when working within a documentary tradition, shift attention to the aesthetic, narrative, and social contexts for their images.

11

There is always a point of view, or, rather, several points of view; and it is this condition that the photographers explore. Thus, while their works critique the representations of Chicanos that appear in art photography, photojournalism, and popular iconography of the United States, their critique relies in part on the very same visual styles and idioms. The result is neither the postmodern parody of quotation or appropriation nor the essential claims of "authentic" counter-documents.[27] Instead, narrative provides a way of subordinating these styles and idioms to a new photographic language able to tell a particular story located at the crossroads of conflicting historical perspectives.

In her accompanying essay in this catalogue, Jennifer A. González examines the visual dialogue between the work in this exhibition and that of other contemporary photographers, a dialogue that creates a negotiated space for Chicano photography as an individual, ethnic, and national artistic practice. In the remainder of this essay, I would like to consider the spaces within and through which the photographers contest the West as History, replacing it with histories-in-relation. While there are other ways to group these photographs, I want to examine three modes: documenting unimagined communities, parodying mass culture, and breaking the code of *entre familia* in order to seek a new synthesis.

DOCUMENTING UNIMAGINED COMMUNITIES:
Harry Gamboa, Jr., and Miguel Gandert

The first mode attempts to document specific communities using the same photographic techniques or styles that have rendered them undocumented within the national culture. These communities are unimagined in two senses: first, their members have a direct experience of each other; second, the community remains outside the national imagination. In "Social Unwest," Gamboa uses his *fotonovela* format to explore the urban West of Chicanos in present-day Los Angeles. In the 1970s, Gamboa appropriated the Mexican *fotonovela* as the basis for a multi-media art form that could mimic and critique the mass media (cinema, television, print news) through the use of available technologies and formats (photography, performance, photocopies). Here, in Gamboa's staged photographs of postmodern urban exiles, assorted friends and family members play out a contemporary struggle of good and evil amid a concrete ghost town in the shadow of downtown LA.[28] The sequential photographs and photocopied character sketches describe a particular group of Chicano artists and writers while also providing an allegorical account of LA's so-called invisible majority.

In "Los Comanches," Miguel Gandert documents the Comanche dances performed by the Indo-Hispano population in northern New Mexico, using three historical styles: the Amer-Indian portraiture of Edward S. Curtis; the landscape tradition in New Mexico, as defined by Paul Strand, Ansel Adams, and Edward Weston; and Gandert's own mode of social documentary and photojournalism.[29] In looking at the Indian and Hispanic identities of rural *mestizo* communities, Gandert calls into question the role of the camera in constructing authentic documents. Historical styles of documentation, including his own, are revealed for the way in which they contribute a visual mythology of racial purity used to narrate the American West. When placed in relationship to each other, however, these styles provide a self-reflexive language for telling a "new" history of *mestizaje* in the West.

PARODYING MASS CULTURE:
Delilah Montoya and Robert C. Buitrón

The second mode uses parody to appropriate formats of mass culture, but does so by foregrounding the ambivalent position of artists as consumers, critics, and producers within that culture. Indeed, if parody usually requires a safe haven, these artists are unable to find it in either high art or mass culture. In "Shooting the Tourist," Montoya photographs tourists at various sites in New Mexico and California, arranging her prints into accordion-fold postcard series that reveal the common activities bridging these different spaces. These black-and-white snapshots, taken with a wide-angle lens, draw attention to the surreal nature of the objective gaze of both tourists and documentary photography—as each attempts to experience the other's *otherness*. In one sense, Montoya shoots tourists against environments that have already been constructed to suit their expectations; and, like a tourist returned home, she places these images of non-contiguous spaces in direct relationship with each other. In using a postcard installation that requires interaction to reconstruct a narrative experience, "Shooting the Tourist" suggests a certain similarity between the tourist and art viewer while it raises a question about Montoya's own location as photographer.

In "El Corrido de Happy Trails (starring Pancho y Tonto)," Robert C. Buitrón provides an off-screen account of those two Western sidekicks, Pancho and Tonto. In this series—as with his earlier photographic parody of the Mexican *calendario* (calendars with Aztec myths), "The Legend of Ixtaccihuatl y Popocatepetl" (1990-1992)—Buitrón provides an insider's critique and reappraisal of Chicano nationalism in the 1990s and an outsider's critique of mass-culture stereotypes, blurring the boundaries between the two locations. Buitrón, who loves the Western, nonetheless identifies it as a genre that frames male identity in terms of Cowboys and Indians. As a child, Buitrón identified with the Indians, tapping into family history and

certain Chicano neo-indigenist fantasies and leading him to play a trick on himself about his racial and cultural background. This series offers a comic, yet complex look at the way in which Chicanos have constructed their cultural identity from, among other things, Hollywood Westerns. Beginning with Hollywood's racialized casting policies, the series examines the mediated construction of cultural identity before introducing Malinche y Pocahontas. These female icons of conquest (from Mexico and the United States, respectively) provide a possible model for subversion within the commodity system of mass culture. The final image, "T.P. Grafix Ponders Missing 'Legends of the West' Postage Stamp," provides an ironic and open-ended commentary on this struggle over cultural capital within national symbolism.[30] After all, having a Mexican American hero on the "Legends of the West" series should raise as many questions as it answers.

ENTRE FAMILIA:
Kathy Vargas and Christina Fernandez

The third mode attempts to subvert national history through the use of family histories and practices—and vice versa. While the phrase *entre familia* usually refers to a silencing strategy to keep criticism within the Chicano family or community, here it marks an effort to place public and private histories in dialogue with each other. In "My Alamo," Vargas pairs photographic images with mixed-media shrines to offer six different views of the Alamo, the "Shrine of Texas Liberty." These include those of her own family, of Hollywood, and of the Order of the Alamo, among others. Vargas produces narrative series that are unique within Chicano photography because of their abstract form—they are done in multiple exposure—and the metaphorical relationship between the images and the stories or memories that motivated them. Here, Vargas also uses live models and autobiographical text in the layered imagery, creating a family photo album and social chronicle going back to 1836. She juxtaposes each of these six images with a mixed-media piece, showing what then gets "enshrined" into history. In her layering and juxtapositions, Vargas is able to question the unequivocal positions different groups have had regarding the Alamo, revealing not just a conflicted public space, but an underlying ambiguity about having to take sides.

In "María's Great Expedition," Christina Fernandez depicts her great-grandmother's remarkable life story, making oblique allusions to the format of Lewis and Clark-style primers and historical museum exhibitions. After leaving her first husband, Fernandez's great-grandmother traveled throughout the Southwest in the first part of the century and encountered an unfriendly country in which she labored and perservered. In the tradition of the documen-

tation of frontiers*men* such as Lewis and Clark, the series consists of maps, drawings, and historical text as well as portrait photographs. In reconstructing a matrilineal oral history of the Mexican frontierswoman as told over three generations, Fernandez depicts her own body refracted through concurrent photographic conventions that were in use between the 1910s and 1950s. At the same time, however, Fernandez resists or downplays personal biography in place of social allegory, identifying neither María as her great-grandmother nor herself as the model. What emerges, then, is a generic life story told through a series of photographic styles—studio portraiture, social documentary, Hollywood publicity still, and amateur snapshot—that have been rendered self-reflexive through various levels of staging. In arranging these as a single narrative, the project represents an internal critique of the documentation of a national history within museum spaces, providing an alternative cultural history for the American West.

If, as noted earlier, these photographers construct their visual language out of problematic styles and idioms, they also end up staging the history that those styles and idioms ignored or stereotyped. Thus, the process of inserting oneself into History, of becoming authentic or acquiring "first voice,"[31] becomes indistinguishable from the revelation that all histories are constructed, invented, or imagined. Even Gandert and Montoya, who set out to document social or cultural groups *in situ*, nonetheless isolate and foreground their most performative aspects: the ritual dances; the experience of a tourist site. Herein lies the dilemma of the many Wests and of the Old West; it is the dilemma of historical narration itself. No one history can be told in isolation from the rest; and all histories cannot be told at once. In staging their histories and drawing upon past and contemporary visual styles, the photographers in *From the West* do not so much get around this dilemma with respect to Chicano history as broaden the audience for its telling.

At the end of their curatorial statement for *American Voices*, Kathy Vargas and Robert C. Buitrón look ahead to a time when Chicano photography will be more widely written about and exhibited, but they also look back in time to an old postcard photograph with the phrase, *"Para un recuerdo—tu primo"* ("As a remembrance—your cousin"), written on the backside. Vargas and Buitrón write of these family images, "gazing at us, waiting to tell us their story," that start the photographers in this exhibition on the path to self-representation, and, ultimately, to something much more nebulous: participation within both local and national histories. If in one way or another family and community histories inform these photographers' images, then constructing a space from which to re-tell these histories to the world at large absolutely haunts them. There is,

after all, the practical matter of funding and exhibition space; but, on a more formal level, there is the question of the translation of cultural and aesthetic references into the national context from which they have been excluded. The challenge is to be two things at once; and, in the interest of reconfiguring the national context, to be willing to see one's individual and ethnic identities transformed as well. The challenge is to live in many Wests.

Research support for this project was provided by the UCLA Academic Senate, Chicano Studies Research Center, Department of Film and Television, and Office of the Chancellor. I wish to thank Amy Schoenborn and Tere Romo for their earlier work in the development of this exhibition, and John Hanhardt and Brian Goldfarb for their helpful advice along the way. Finally, as always, I am indebted to Gabrielle James Forman for being the best editor around, east or west.

NOTES

[1] Eric Foner and Jon Wiener, "Fighting for the West," *The Nation*, 29 July/5 August 1991, 163.

[2] See Patricia Nelson Limerick, *The Legacy of Conquest: The Unbroken Past of the American West* (New York: W.W. Norton, 1987), 26. See also Gerald D. Nash, *Creating the West: Historical Interpretations, 1890-1990* (Albuquerque: University of New Mexico Press, 1991).

[3] See, for example, Patricia Nelson Limerick, "The Adventures of the Frontier in the Twentieth Century," in *The Frontier in American Culture*, ed. James R. Grossman (Berkeley: University of California Press, 1994), 66-102.

[4] Quoted in George N. Fenin and William K. Everson, *The Western: From Silents to Cinerama* (New York: The Orion Press, 1962), xx.

[5] It is of note that historians often compare Hart's films to the works of Frederic Remington and Charles M. Russell and to documentary photography of the Old West. See, for example, Fenin and Everson, *The Western*, 75; and Edward Buscombe, ed., *The BFI Companion to the Western* (New York: Da Capo Press, 1988), 30.

[6] On the nineteenth century, see Tomás Almaguer, *Racial Faultlines: The Historical Origins of White Supremacy in California* (Berkeley: University of California Press, 1994); and Alexander Saxton, *The Rise and Fall of the White Republic: Class Politics and Mass Culture in Nineteenth-Century America* (London: Verso, 1990). On the twentieth century and Mexican American struggles for civil rights and "first-class citizenship," see Mario T. García, *Mexican Americans: Leadership, Ideology, and Identity, 1930-1960* (New Haven: Yale University Press, 1989).

[7] Benedict Anderson, *Imagined Communities: Reflections on the Origin and Spread of Nationalism*, revised edition (New York: Verso, 1991), 6-7. Anderson concludes: "Ultimately it is this fraternity that makes it possible, over the past two centuries, for so many millions of people, not so much to kill, as willingly to die for such limited imaginings."

[8] On imagined communities and invented traditions, see Anderson, *Imagined Communities*; and Eric Hobsbawm and Terence Ranger, eds., *The Invention of Tradition* (Cambridge: Cambridge University Press, 1983).

[9] Quoted in Jorge G. Castañeda, *Utopia Unarmed: The Latin American Left after the Cold War* (New York: Vintage Books, 1993), 283.

[10] I borrow Doris Sommers's phrase for the nineteenth century romances in Latin American fiction in which sexual unions became allegorical of concurrent nationalist movements and nation-building projects. See her *Foundational Fictions: The National Romances of Latin America* (Berkeley: University of California Press, 1991) and Blaine P. Lamb, "The Convenient Villian: The Early Cinema Views the Mexican-American," *Journal of the West* 14.4 (October 1975): 75-81.

[11] Charles F. Lummis, *The Land of Poco Tiempo* (New York: Charles Scribner & Sons, 1913), 8-9.

[12] Enrique R. Lamadrid, "Ignoble Savages of New Mexico's Silent Cinema, 1912-1914," *Spectator* 13.1 (Fall 1992): 14; see also Sylvia Rodríguez, "Art, Tourism, and Race Relations in Taos: Toward a Sociology of the Art Colony," *Journal of Anthropological Research* 45.1 (Spring 1989): 77-99.

[13] Carey McWilliams, "Southern California: Ersatz Mythology," *Common Ground* (Winter 1946): 38.

[14] It is ironic, of course, when sincere efforts to debunk the myth of the West end up perpetuating the "Mexican" as a structured absence; for example: Jane Tompkins, *West of Everything: The Inner Life of Westerns* (Oxford: Oxford University Press, 1992); Chris Bruce, ed., *Myth of the West*, exhibition catalogue (New York: Rizzoli International Publications, 1990); and Buscombe, ed., *The BFI Companion to the Western*.

[15] Richard Slotkin, *Gunfighter Nation: The Myth of the Frontier in Twentieth-Century America* (New York: HarperCollins, 1992), 61.

[16] See Virginia Wright Wexman's discussion of dynastic marriage in Westerns, in chapter 3 of *Creating the Couple: Love, Marriage, and Hollywood Performance* (Princeton: Princeton University Press, 1993).

[17] Frederick Jackson Turner, "The Significance of the Frontier in American History" (1893), in *Frederick Jackson Turner: Wisconsin's Historian of the Frontier*, ed. Martin Ridge (Madison: The State Historical Society of Wisconsin, 1986), 27.

[18] Jules David Prown discusses this "erasure" of other points of view as a function of the art itself in his "introduction" to the exhibition catalogue, *Discovered Lands, Invented Pasts: Transforming Visions of the American West* (New Haven: Yale University Press, 1992), vii-viii.

[19] See chapters 31, "The Indian Renaissance," and 32, "Montesuma's Revenge," in William H. Groetzmann and William N. Groetzmann, *The West of the Imagination* (New York: W.W. Norton & Company, 1986), 398-421. The latter deals with murals of the Chicano Movement as well as contemporary artists Luis Jiménez and Mel Casas.

[20] This observation allows us to take a second look at the most controversial of the recent Western exhibitions, the Smithsonian's *The West as America*, which set out to "trace the way artists enlisted their talents in the service of progress during the period of westward expansion in America." This studious effort at historical revisionism, which drew considerable conservative crossfire from Capitol Hill, nonetheless fails to mitigate a task-force report that concluded, "The Smithsonian Institution almost entirely excludes and ignores the Latino population of the United States." William H. Truettner, ed., *The West as America: Reinterpreting Images of the Frontier, 1820-1920* (Washington: Smithsonian Institution Press, 1991), vii; and Smithsonian Institution Task Force on Latino Issues, *Willful Neglect: The Smithsonian Institution and U.S. Latinos*, Washington, D.C., May 1994.

[21] Kevin Starr, "Moving Beyond the Turner Thesis," in Martin Ridge et al., *Writing the History of the American West* (Worcester: American Antiquarian Society, 1991), 126.

[22] Castañeda, *Utopia Unarmed*, 288.

[23] Starr, "Moving Beyond the Turner Thesis," 126. In fact, Chicano art exhibitions often invoke other spatial orientations, most notably the Northern perspective from Mexico. See, for example, Amalia Mesa-Bains's extensive essay in the exhibition catalogue, *Art of the Other Mexico: Sources and Meanings* (Chicago: Mexican Fine Arts Center Museum, 1993), 14-73.

[24] For a more nuanced and critical account of Chicano histories, see Alex Saragoza, "Recent Chicano Historiography: An Interpretive Essay," *Aztlán: A Journal of Chicano Studies* 19.1 (1988-1990): 1-77. In the 1960s, Chicano activists—poets, writers, and artists among them— sought to stand outside this set of relations altogether by postulating another spatial orientation, Aztlán, "the lands to the north." As mythical homeland of the Aztecs, Aztlán need not look anywhere else, nor could it be looked toward, except from the distant past. In its more extreme expressions, Aztlán was no less nativist and nationalist than the "love it or leave it" American patriotism of the times. In either case, one was not so much from a place as the embodiment of place, to the detriment of everyone else. Still, Aztlán, like earlier conceptions of a "lost land" within Mexican-descent communities, offered an alternative, if utopian, geography from which Chicanos could negotiate ethnic identity and civil rights within the United States. For a recent and provocative exhibition organized around the concept of Aztlán, see Armando Rascón, *Xicano Progeny: Investigative Agents, Executive Council, and Other Representatives from the Sovereign State of Aztlán* (San Francisco: The Mexican Museum, 1995).

25 As Howard R. Lamar notes, "This is a debate that cannot end until there is a new synthesis which simply is not in sight yet." See Lamar, "Commentary," in Ridge et al., *Writing the History of the American West*, 111.

26 See the brief overeiew of Mexican photographic images and the exhibition history of Chicano photography in Robert C. Buitrón and Kathy Vargas's curatorial statement "*Para un recuerdo:* Photography by Chicanas and Chicanos," from the exhibition, *American Voices: Latino/Chicano/Hispanic Photography in the U.S.*, Fotofest '94, Houston, Texas, November 10-30, 1994.

27 Abigail Solomon-Godeau makes a similar argument with respect to Armando Rascón's piece *Artifact with Three Declarations of Independence* (1991) in the exhibition catalogue, *Mistaken Identities* (Santa Barbara: University Art Museum, 1993), 63.

28 See Harry Gamboa, Jr., "Urban Exile," *Artweek*, 20 October 1984, 3.

29 Gandert even uses reproductions of Edward S. Curtis's original frames for his Amer-Indian portraiture.

30 See, for example, José Antonio Burciaga's editorial on the absence of Mexican Americans from the U.S. Post Office's recent "Legends of the West" series: "Stamp of Approval for Mexicanos," *Los Angeles Times*, January 3, 1995, B5.

31 The concept of "first voice" informs a number of recent advocacy efforts within the national arena; for example, the formation of the National Association of Latino Arts and Culture and the multi-volume publication project, *Recovering the U.S. Hispanic Literary Heritage.* See *Crossing Borders/Cruzando Fronteras: Los Siguientes 500 Años/The Next 500 Years*, 1992 Conference Proceedings (San Antonio: National Association of Latino Arts and Culture, 1994); and Ramón Gutiérrez and Genaro Padilla, eds., *Recovering the U.S. Hispanic Literary Heritage* (Houston: Arte Público Press, 1993).

NEGOTIATED FRONTIERS:
Contemporary Chicano Photography

Jennifer A. González

> *"A Chicano is a Mexican-American*
> *with a non-Anglo image of himself."*

Ruben Salazar[1]

WHAT DOES IT MEAN *to have*, or indeed *to be with*, an image of oneself? How is that image constructed? How is that image controlled? To *have an image* implies the rights of ownership. To *be with* an image implies a relation of cooperation, community. Each of the artists in this exhibition reflects on this problematic duality of *being with* and *having* an image of self or community. To this degree they participate in the larger questions circulating in contemporary art of the late twentieth century—questions raised particularly within the realm of photography. At the same time, as "Chicano/a" photographers, these artists confront issues that are culturally specific and unique. The process of locating Chicano photography within a larger discourse on contemporary photography, then, is not unlike searching for an elusive document.

My purpose in this brief overview is to draw loose parallels between the work in this exhibition and the work of other contemporary photographers. I do not, however, seek to privilege one context over another through an exercise in inclusive canonization. Rather, my goal is to set up a series of resonances that suggest the negotiated space through which photographic images are formally and conceptually constructed.

The work in this exhibition offers a double challenge to the viewer: first, to grasp the historical, political, and cultural narratives that are being told; and second, to reflect upon the formal concerns that determine how these narratives can be read. Because one necessarily relies upon the other—that is, the meaning of historical and cultural narratives is determined by the way in which they are told, and the formal mode of telling is shaped by the elements of the narrative—it is impossible to reduce these works of art to a simple one-to-one correspondence with the works of other contemporary photographers. Insofar as the stories presented by these Chicano/a photographers are unique and culturally specific, so too will be the form of telling. Through this series of formal and conceptual comparisons, I wish to show how and where the artists in this exhibition engage in a visual dialogue within contemporary photography and, as a result, transform the boundaries of photographic representation.

TELLING HISTORIES

It is probably best to begin with a short historical account of the relations between Chicano art and narrative photography. Narrative (as story-telling) has no doubt been linked with photography for as long as the medium has served to illustrate momentous events and ordinary people. In the fine arts, however, the link between narrative and photography—following a significant break in the mid-twentieth century when modernist aesthetics prevailed[2]—was revived in the 1960s when artists in other media started to incorporate more representational and figurative elements in their work. Photography, with its apparently endless possibilities of "real life" story-telling, seemed the ideal medium to represent a new visual agenda that emphasized representation over abstraction.[3]

It was also during this period (1965–1970), when the fine arts began the slow shift from modernist concerns to the narrative forms and political commentary current in much contemporary work, that Chicano art blossomed in the United States. This was not mere coincidence, since it is clear that the formal shifts in artistic paradigms and the demands made by the social movements of this period were in a tight symbiosis. Changing conceptions of the role of art, especially as a revived domain for political action, can be directly traced to the effects of criticisms raised by feminists and civil-rights activists who sought to reveal the

Jennifer A. González teaches at the Rhode Island School of Design and has published articles in *Visual Anthropology Review* and *Diacritics*. She is completing her Ph.D. dissertation in the History of Consciousness Program at the University of California, Santa Cruz.

dangers of patriarchal and ethnocentric ways of seeing and evaluating art. Included in this critical analysis was a demand for the production and presentation of new, untold narratives.

The art of the Chicano *movimiento* developed in parallel with this paradigm shift in visual representation.[4] Perhaps most powerfully present in large-scale murals and theatrical productions, the early recuperation and reinvention of history through the narrative arts played a central role in galvanizing support for community activism. During this early consciousness-raising period, the photograph primarily functioned as documentary evidence of economic hardship and political struggle or, alternatively, as a memento of Mexican or indigenous ancestry and practices.[5]

In the last fifteen years, however, many Chicano/a artists have transformed this legacy of documentary photography into a powerful tool for the formation of a new visual language, one that is self-conscious of its own production. Still interested in the projects of memory, history, and narrative that have been the base of efforts to build community identity and solidarity, the artists here have also begun a visual dialogue with the formal concerns of other contemporary photographers.

REDEFINING THE DOCUMENTARY GAZE

Miguel Gandert's *Los Comanches*, which documents the dances performed by Comanche societies in northern New Mexico, functions, to a certain degree, in the tradition that uses the photograph as an authentic trace of what was photographed. But Gandert has also made this tradition of authentication the underlining subject of his work, dividing his series into three parts to highlight the semantic differences between portrait, landscape, and social documentary. Intentionally shot and mounted to resemble portrait photographs by Edward S. Curtis (famous for his "stoic" images of indigenous peoples taken between 1907 and 1930), Gandert's portraiture also references the fashion aesthetic of Richard Avedon's *In the American West* (1985). In the case of both photographers, the content of the image is removed from any social or historical context not directly visible on the subject's body. The body itself becomes the sign of culture. Community, activity, and volition are erased in order to reveal the "pure" identity of the individual, and, as a consequence, the West becomes defined by the solitude of its inhabitants. Avedon, according to one critic, portrays the West "as a blighted culture that spews out casualties by the bucket."[6] In his work, the inhabitants are isolated by the camera from their daily habitat and have little to provide but confirmations of already circulating stereotypes. A critique of this mode of viewing can be found in David Avalos's *Wilderness* (1989), in which *wilderness* is literally

written over a series of anonymous portraits of indigenous people. In contrast, the first images in Gandert's series emphasize the quiet beauty of his subjects, thereby reproducing the solitary portraiture of Curtis and Avedon. To this degree, the photographs send stereotypes recirculating—and, at the same time, they emphasize the formal means through which such stereotypes are originally constructed.

Gandert's critical exploration of documentary becomes more explicit as the viewer is led along a sequence of images that becomes both decreasingly romantic and increasingly prosaic. By replacing the portrait with the landscape—quoting the tradition of Edward Weston and Ansel Adams, and their many contemporary followers, which continues to see the West as a frontier of wide open spaces occupied by heroic figures—Gandert nevertheless allows small bits of technological contamination to enter into the image. Sweeping panoramas replace cropped close-ups, but perceptions of the Comanche as distanced from the viewer by time and culture are subtly undermined by the presence of contemporary material signs such as automobiles parked in the background and power lines that cut across an otherwise expansive sky. The images reveal that both kinds of distance—the emptiness of the close-up and the anonymity of the landscape—produce a visual argument for an "authentic" subject. To subvert this reading, details within the photograph indicate the inherent contradictions and necessary mendacity that have characterized the framing process of traditional Western photography.

Gandert ends the series with his own documentary style, which relies on a snapshot aesthetic of contextual placement and medium range that is common in tourist photography and photojournalism. Unlike those tourists, however, who tirelessly strive to remove all of what they believe to be the non-authentic or extraneous information from the margins of their images, Gandert is more concerned to produce a clear indication of the relationship between the artist and his contemporary subject.

In each formal mode, the photographs in the series quote a photographic style in order to point to the socially constructed nature of its form. Martha Rosler writes,

> In general, it is through irony that the quotation gains its critical force. One speaks with two voices establishing a kind of triangulation — (the source of) the quotation is placed *here*, the quoter over *here*, and the hearer/spectator *there* — and, by inflection, one saps the authority of the quote. Irony, however, is not universally accessible, for the audience must know enough to recognize what is at stake.[7]

The meaning of any photographic quotation, as Rosler also notes, is heavily weighted by the process of framing the

image. The authority of vision dictated by a photographer such as Edward S. Curtis is usurped in Gandert's series through framing and juxtaposition. Gandert necessarily takes a risk in using quotation to produce a critical view of documentary photography because he risks encountering an audience that may or may not recognize what is at stake in the images. Unlike other contemporary photography of quotation that emphasizes irony as a loss of meaning, however, Gandert's series situates its subjects in a context of formative social encounters that move beyond surface effects of photographic style to reclaim a self-critical, photographic presence.

Delilah Montoya also takes part in this critical assessment of the cultural role of photography. Her goal is to document the view, and to return the gaze, of the tourist camera. Making a clear reference to such photographs as Lee Friedlander's *Mount Rushmore, South Dakota* (1969), Montoya is in a long tradition of photographers who have used the camera to reveal the voyeuristic nature of the tourist or, as Chon Noriega has observed in his essay in this catalogue, the touristic nature of the art viewer.[8] To the degree that her work emphasizes this layered complicity of voyeurism, it can also be compared with British photographer Susan Trangmar's *Untitled Landscapes* (1986), or German photographer Thomas Struth's museum series (1989–1994) in which one sees the backs of individuals as they contemplate cityscapes or fine art. In the work of Trangmar and Struth, the viewer's own role in a system of observation or surveillance is made manifest—as duplicated in the photographer's gaze—and thereby foregrounds the context of museum or gallery where the work is exhibited. A sense of static distance pervades the work of both artists, in part because of the large-format negatives or wide-angle lenses they use, but also because the camera is located away from the action of the image, safe and aloof. In contrast, Montoya's framing tends to be looser and is set in the middle of the action it depicts. As a result, it is not only more in keeping with a tourist sensibility, but it also removes the viewer from a metaphorical position of physical or institutional dominance. Montoya succeeds, as do Trangmar and Struth, in making her audience aware of its role in a system of looking both by emphasizing its position as audience and by locating it as the object of the gaze. By inserting herself in the line of sight of other tourist photographers, Montoya reproduces the visual sensation of having one's picture taken. In her photographs, the viewer is not put in the position of tourist, but rather in the position of a consumable cultural artifact. This is made more concrete by her use of postcard series rather than conventional exhibition prints. Montoya thus reflects upon the ways in which the peoples of the West—both native and nonnative—construct their relations of identity around *being*

an image for, or *having* an image of, each other. In so doing, Montoya demonstrates an interest in the construction of cultural identity as well as the role of the camera in this process.

TEXTUAL TRACES

There are two distinct kinds of narrative photographs: those with an accompanying text and those without. This distinction applies to single, multiple and sequential photographs. In narrative photography, there is always an implied directional reading of events, although sometimes the viewer is initially not aware of it. As Max Kozloff remarks, "The job of the narrative photographer is to suspend our sense of the irreversible lateness of our arrival at the scene depicted, and to try to re-situate viewers within an apparently emergent process, still unconsummated at the moment of perception."[9] When a narrative is constructed from visual fragments alone, as in the work of Gandert and Montoya, the formal tropes of the image (its framing, its depth of field, its choice of tone and aspect) nevertheless constrain the way it will be read. Chains of associations will follow from each individual element in the photographic image until a sequencing or sense is constructed. As artist and theorist Victor Burgin points out, this reading might be accomplished, "not in a linear manner, but in a repetition of 'vertical' readings, in stillness, in a-temporality."[10] However, when text accompanies the photographic image, a linear or prescribed reading is set in motion as the eye swings slowly like a pendulum, or flits quickly like a fly, between image and text.

Many contemporary photographers, from the 1970s onward, have made use of the anchoring possibilities of text in their work, some to create political or metaphorical juxtapositions with an image, others to produce a narrative context.[11] In this exhibition, the use of text in Harry Gamboa, Jr.'s, *Social Unwest*, Kathy Vargas's *My Alamo*, and the biographical materials that accompany *Maria's Great Expedition* by Christina Fernandez can be read through and against this body of work. I do not wish to suggest that these works can be reduced to their use of textual materials; only that, in each case, the written word functions differently in the construction of a skeletal framework through which a visual narrative can be read.

In *Social Unwest*, Gamboa's use of text defines not a plot structure, but a cast of characters. Rather than telling a story, the brief statements printed on the back of nine portrait photographs, and made available to each audience member in stacks of xeroxed flyers, reveal first-person accounts of what might be a Chicano life in a city of unrest. When these actors take on melodramatic roles in the highly staged series of performance events Gamboa photographs, the work formally recalls Robert Longo's large-scale, black-

and-white drawings known as the "Men in the Cities" series (1981–1987). Both share a tone of theatricality and create a playful caricature of stereotypes; yet Gamboa's community of figures in *Social Unwest* exhibits a greater range and sense of humor than Longo's solitary, homogeneous and anonymous figures, who appear to waver between a late-capitalist pleasure and angst. It is precisely because they are *not* anonymous, but rather identifiable through a textual mapping of character effects, that Gamboa's figures also function more powerfully as sources for viewer identification. The audience in this case can both literally *have* an image of a "real" Chicano and also *be with* this image in the sequence of imagined city-scapes that Gamboa presents.

This sequential presentation of images in Gamboa's piece shares aspects of cryptic narrative and accumulation of evidence found in the early work of Duane Michals and in more recent work by artists such as John Baldessari, Eve Sonneman, or Carrie Mae Weems, who use careful staging or provocative juxtapositions to produce the feeling of an actual event. Gamboa's work is also built upon the staging of events, but it is differently inflected by the cross-genre appropriation of visual tropes from television, film, and theater—a multi-media genre that he began to identify as the *fotonovela* in the 1970s. The term *fotonovela* originally described a popular Mexican comic-book genre that replaces drawn images with photographs. While other artists have used the *fotonovela* as an inspirational source— for example, Puerto Rican artists Merián Soto and Pepón Osorio in *No Regrets* (1988)—Gamboa uniquely interprets the term to define his own narrative manipulation of photographic prints and slides, recorded sound, and spoken and written texts. In sequencing photographs, Gamboa marks a passage of time; but as with any chronology, there are gaps in the story. It is Gamboa's almost aphoristic textual commentary—the voices of his community—that functions to guide the viewer across and through the narrative expanse of this urban un-West.

Christina Fernandez uses descriptive text even more explicitly as a guiding device in *María's Great Expedition.* Here the artist maps out an extraordinary woman's everyday life history. In providing the visual traces of a private life through the formal structure of a museum-style exhibition, complete with wall text and cartographic information, Fernandez can be seen to participate in a current wave of what one scholar has called *museumism.*[12] While less explicitly concerned with the critique of institutions that informs work by such artists as James Luna and Fred Wilson, Fernandez nevertheless uses the formal devices of a museum exhibition to raise questions concerning the authority of evidence in determining the history of any given community.

A set of visual contradictions within the work marks it as the site of semantic ambivalence concerning the difficult task of recuperating an undocumented history. While the written text and installation format make reference to an authentic history and biographical narrative, the photographic images simultaneously undermine the literalness of any purely historical interpretation. The oddly still and stylized portraits can be formally compared with works by photographer Cindy Sherman, particularly her early *Untitled Film Still* series (1977–1980). In both artists' work there is an emphasis on a staged event or moment in which a single female protagonist, in each case played by the photographer, poses in the midst of action or contemplation. Neither accidental nor documentary, these images do not take part in a realist aesthetic. Instead, both artists emphasize the artificial formalism of the constructed photographic space while gesturing toward the historical period the staged context implies. In Sherman's photographs, however, the figure of the woman is in each case constructed as a different character caught in the dramatic unfolding of filmic events. Indeed, part of Sherman's strength is found in the *variety* of types she is able to construct; whereas, for Fernandez, the "factual" identity of the protagonist is central to her project.

The story that grounds Fernandez's work is the life story of her great-grandmother, a woman who survived in many different contexts during the first half of this century, but who always retained an individual identity. Whether or not the audience is aware that Fernandez herself stands in for this ancestral figure, the placement of a young woman in this role implies that there is an overlapping of identification between generations. The protagonist, María, does not age over time, but always retains the same youthful form; only her context, costume, and photographic format change. Fernandez thus highlights, as does Gandert, the contemporary use of photography as an evocative metaphor, rather than an authentic trace, in the construction of historical narration. To *be with* an image is in this case to *be in* an image, taking on the metaphorical form, if not the literal content, of history.

In the case of Kathy Vargas's *My Alamo*, the form of the photograph dictates that the content will be read as a series of depth relations. Similar to Tommie Arai's photo-silkscreen series *Memory in Progress: A Mother/Daughter Project* (1988) and Lorie Novak's *Past Lives, Fragments* (1987), the use of photomontage, or in this case multiple exposure, in *My Alamo* produces a poignant sense of shifting temporality. In the way one might imagine the juxtapositions that take place in wandering through a landscape of memory, Vargas superimposes objects, bodies, and texts in such a way as to evoke a narrative reading. Each layer can be read as informing the next, bleeding through to structure the possible significance of each subsequent element. The

20

written commentary in the work does not act to anchor the images as much as it appears as one fragment among others in an open system of associations.

The decision to pair each of her photographs with a memorial shrine links the work of Vargas with other contemporary installation artists such as Christian Boltanski (*Leçon des Ténèbres*, 1987), Amalia Mesa-Bains (*Venus Envy*, 1993), and Jenni Lukac (*Votive Shrine*, 1992). Each of these artists, in very different ways, seeks to emphasize the role of photography in a system of representation that transforms historical events into sacred memories for a given community. For Vargas, the shrine functions as the site through which the image is defined and located within the context of individual relations and cultural institutions. Albert Chong (*The Two Generations*, 1990) and Adolfo Paniño (*Elements of Navigation*, 1991–1992) also have in common Vargas's interest in the use of material traces, objects, and photographs to map the complex negotiations of cultural identity; but in the case of these two artists, the photograph retains a kind of authenticity and still functions as an indexical trace of a "real" historical moment. In using multiple exposures, Vargas purposefully embraces a photographic process that has been, and, in some schools of thought, is still considered taboo for its lack of purity, but it is this very notion of purity that Vargas actively wants to subvert in *My Alamo*. Her ambivalent relation to this South Texas monument can be traced back to the experience of being asked to take sides in relation to the history of U.S.-Mexico antagonism. What Vargas makes clear is the impossibility of taking one side or another, of locating a pure identity. Her work maps the complexity of having an image of the past that is always situated within a larger context of historical monuments and social institutions.

REVIEWING HOLLYWOOD

Among contemporary artists working with photography and the question of the West, David Levinthal is perhaps one of the better known for his glamorous, monumental, Hollywood-style cowboy and Indian images. His series *The Wild West* (1993) revives a pseudo-nostalgia for the West-as-frontier through close-up, shallow-focus photographs of toy figurines. Cowboys are seen roping horses and cattle, Indians are seen attacking covered wagons and fighting with cowboys, and women are seen waving to trains or looking off into the distance and holding a child. In short, the West according to Hollywood. The irony of Levinthal's project is that it is *not* ironic, it is sincerely nostalgic.[13] Robert C. Buitrón's project, "El Corrido de Happy Trails (starring Pancho y Tonto)," can be read as a critical response to, and filmic elaboration of, this nostalgia. While Levinthal places the Euro-American cowboy at the center of his work, Buitrón examines the role of the Indian (Tonto), which in many instances also translated into the Mexican (Pancho). Consistent with a recuperative reading of genre, Buitrón revises the Hollywood Western to find his own place in the narrative. At the same time, as Chon Noriega points out, Buitrón projects his own nostalgia for this genre and his desire to be part of a certain neo-indigenist fantasy. The images he produces are decidedly ironic in their representation of multiple sign systems (computer screen, poster, costumed characters) that set up a context for possible sites of identification. But just as "Pancho y Tonto" must look for their own place in the film industry through the casting agency, so too must the audience define their own relation to these iconic figures of the Hollywood Western. Unlike Levinthal's literal resuscitation of Western fantasies, Buitrón's images present his audience with new historical possibilities.

NEGOTIATED FRONTIERS

I would like to conclude this brief discussion of how the six artists in the exhibition work within a general framework of contemporary visual culture, and in conversation with other contemporary artists/photographers, by addressing two questions. The first is how these artists, as specifically Chicano/a photographers, form a unique visual culture within the world of contemporary photography. The second is the question I began with—what does it mean for these artists to *be with* or to *have* an image of one's self or community?

Robert C. Buitrón and Kathy Vargas point out in their essay "*Para un recuerdo:* Photography by Chicanas and Chicanos," that Chicano photography has yet to define itself as a school or style, whether as an historical form or contemporary visual practice.[14] As the artworks in this exhibition are formally eclectic, the threads that tie them together are therefore their shared ideological concerns. What distinguishes this work as a separate domain within the context of contemporary photography is its culturally specific reading of historical events in combination with an activist vision of the future, a future in which racism does not predominate in the field of visual culture. While working with themes that can be found in much late twentieth-century photography—the family, the city, tourism, narrative figures—this work creates a new set of visual icons that inhabit a contested terrain in which distinctions between the marginal and mainstream are no longer clear. It is significant that Fernandez represents a woman with Spanish-style curls by the railroad tracks, or that Gamboa includes "gang" figures in his Los Angeles territorial tug-of-war, or that Vargas pictures the Alamo in her layered images. These details are legible icons within a community that has shared in the cultural moments they represent, a community in this case identified as Chicano. Yet

these discrete material details, these over-determined signs, can also be seen to circulate in the culture at large—a visual culture that includes Hollywood Westerns, television soap operas, tourist postcards, and romantic documentary. The space in which these artists' images are meaningful is thus the frontier between domains (for example, the "authentic ethnic" and the "self-critical avant garde") that have been artificially created and then kept purposefully separate in the discourse of fine arts.

In the context of an exhibition, it is not only the artist but also the viewer who inhabits this frontier space; for a photograph is defined not only by its material form but also, and more importantly, by its audience. In narrative photography, this is always the case. Max Kozloff succinctly remarks, "As the writer solicits the reader, so does the camera eye solicit the viewer, insinuating itself as an alter ego of the viewer. Narrative greatly depends on this primitive transference, so that, case by case, the story formulates a personality for its spectator."[15] The photography in this exhibition postulates an audience whose "personality" is determined in part by specific memories and identities that are generalizable to Chicano communities across the West, and in part by a literacy for the formal devices and popular-culture references the artists skillfully manipulate. As a result, what emerges in this exhibition is an emphasis, not on the identity of the individual or the community, but on *relations between* individuals and communities.

The photographic image is used as part of the process of re-defining these relations. Each artist in *From the West* puts the difficulty of *having* or *being with* an image into a new conceptual framework. Questions of ownership—the right to assign meaning and the privilege of commodification and distribution, as well as the liability of authenticity—are raised in the work of Buitrón, Gandert, and Montoya as they explore what it means to *have* an image. Questions of existential relations—territorial alliances, shifting social roles, processes of identification—can be found in the works of Fernandez, Gamboa, and Vargas as they delimit what it means to *be with* an image. For these Chicano/a photographers, *having* or *being with* an image is thus part of negotiating the visual, historic, and cultural frontiers of a new American West.

NOTES

[1] Ruben Salazar, "Who Is a Chicano? And What Is It the Chicanos Want?" *Los Angeles Times*, 6 February 1970, p. B7; reprinted in Salazar, *Border Correspondent: Selected Writings, 1955-1970*, ed. Mario T. García (Berkeley: University of California Press, 1995).

[2] Max Kozloff notes, "The serious Modernist could make signs and evoke symbolic meanings, but was prohibited from regressing so far as to tell a story." "Through the Narrative Portal," *Artforum* (April 1986): 86.

[3] See Jon Thompson, "The Spectral Image," in *Ghost Photography: The Illusion of the Visible* (Milano: MystFest and Idea Books, 1989).

[4] For an overview of Chicano art, see Shifra Goldman and Tomás Ybarra-Frausto, *Arte Chicano: A Comprehensive Annotated Bibliography of Chicano Art, 1965-1981* (Berkeley: Chicano Studies Library Publications Unit, University of California, 1985); and Richard Griswold del Castillo, Teresa McKenna, and Yvonne Yarbro-Bejarano, eds., *Chicano Art: Resistance and Affirmation*, exhibition catalogue (Los Angeles: Wight Gallery, University of California, Los Angeles: 1991).

[5] See Elizabeth Martinez, ed., *500 Años del Pueblo Chicano/500 Years of Chicano History in Pictures* (Albuquerque: SouthWest Organizing Project, 1991); and Robert C. Buitrón and Kathy Vargas, "*Para un recuerdo*: Photography by Chicanas and Chicanos," curatorial statement for the exhibition *American Voices: Latino/Chicano/Hispanic Photography in the U.S.*, Fotofest '94, Houston, Texas, November 10-30, 1994.

[6] See Max Kozloff, "Through Eastern Eyes," *Art in America* (January 1987): 90-97.

[7] Martha Rosler, "In, Around, and Afterthoughts (on documentary photography)," in *The Contest of Meaning* (Cambridge, MA: MIT Press, 1989), 326.

[8] For examples of art about tourism see *SITEseeing: Travel and Tourism in Contemporary Art*, exhibition catalogue (New York: Whitney Museum Downtown, 1991).

[9] Kozloff, "Through the Narrative Portal," 88.

[10] See Victor Burgin, "Seeing Sense," *The End of Art Theory* (Atlantic Highlands, NJ: Humanities Press International, 1986), 69-70.

[11] Artists such as David Avalos, Celia Alvarez Muñoz, Christian Boltanski, Deborah Bright, Victor Burgin, Sophie Calle, George Legrady, Karen Knorr, Esther Parada, Lorna Simpson, Mitra Tabrizian, Carrie Mae Weems and many others have found unique uses for linguistic text in combination with the visual text of the photograph.

[12] See Lisa G. Corrin, "Mining the Museum: Artists look at Museums, Museums Look at Themselves," in *Mining the Museum*, exhibition catalogue (Baltimore: The Contemporary, 1994).

[13] See the interview in *The Wild West: Photographs by David Levinthal*, Photographers at Work Series (Washington, DC: Smithsonian Institution Press, 1993).

[14] Buitrón and Vargas, "*Para un recuerdo*."

[15] Kozloff, "Through Eastern Eyes," 97.

EXHIBITION

El Corrido de Happy Trails
(starring Pancho y Tonto)

ROBERT C. BUITRÓN

At the age of twelve, my *abuelito*, Antonio Aguirre Oltiveros, worked on the chuck wagon of one of the last overland cattle drives in Texas, circa 1916. His background, which I mystified and romanticized with the help of Hollywood, had an even greater significance for me since he was also part Mescalero . . . Apache. But the American society of his time most likely tempered his self-image: He declared himself *Mexicano*. I didn't want him to be a Mexican. As a boy, I wanted him to be an Indian, so that I could claim to be Indian (or at least part). After all, television, Hollywood, and history textbooks relegated Mexicans to the margins of frontier myth, portraying them as untrustworthy half-breeds. So, like other boys, I leaped innocently into the marketing control of Disney and company wearing coonskin caps, buckskin jackets, and cowboy boots. We hunted the streets, yards, and railroad woodlands like Davy Crockett. We hunkered down and scanned the horizon for Indians like seasoned John Waynes, ready to die with our boots on. But not one Mexican existed in the shadows of the American presence and the Indian absence.

Only later did I realize that the American frontier myth did not provide any other choice; the protagonists were either cowboys or Indians. Although Hollywood employed Mexican actors, there were very few Mexican heroes or heroines on the screen. Whom should I emulate? The dirty, untrustworthy *mestizo*, or the lazy, docile Mexican? If Ricardo Montalban could play Indians, why couldn't I? Didn't I have a legitimate ancestral claim? These questions do not have easy answers, especially for a Chicano with Indian ancestry raised by American popular culture. Once upon a time, the Mexican and the Apache were enemies. Now Chicanos and Indians have formed an alliance: Pancho y Tonto have left their sidekick roles and taken to the Happy Trails. What follows is one episode in their journeys into the American frontier myth.

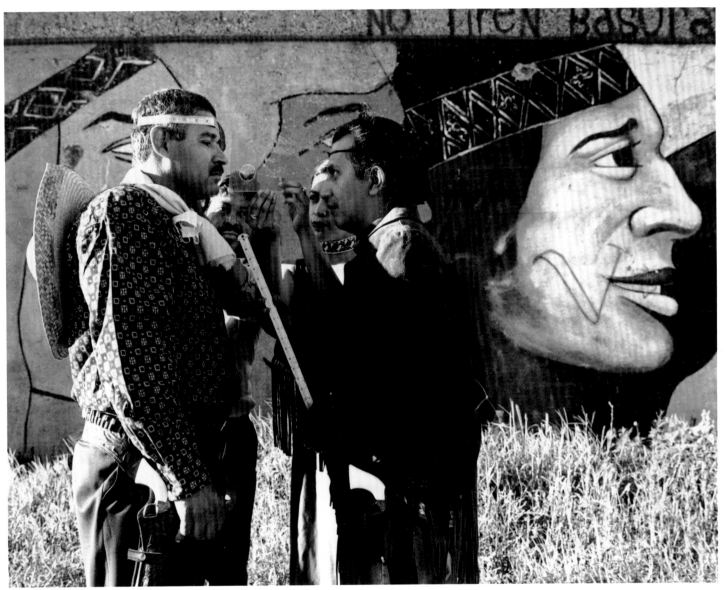

"Pancho Asks Tonto if He's más indio que español"

25

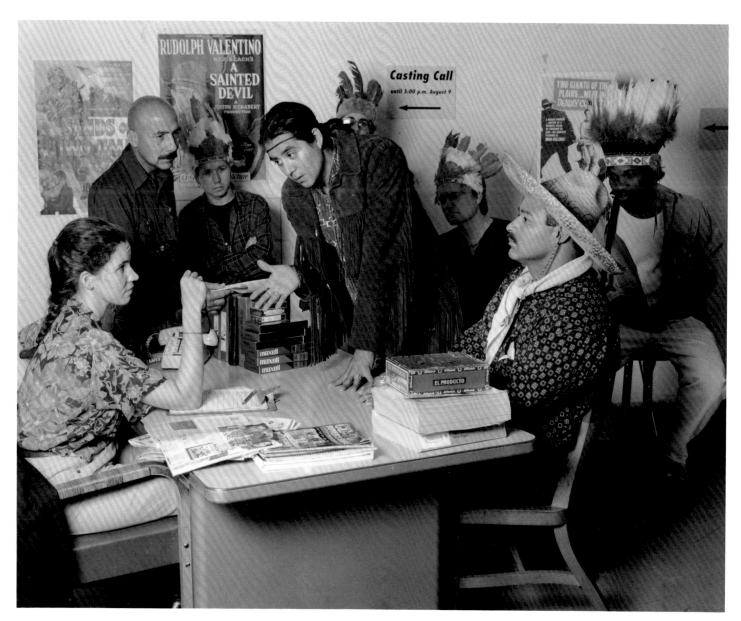

"Seeking Indians — Mexicans Need Not Apply"

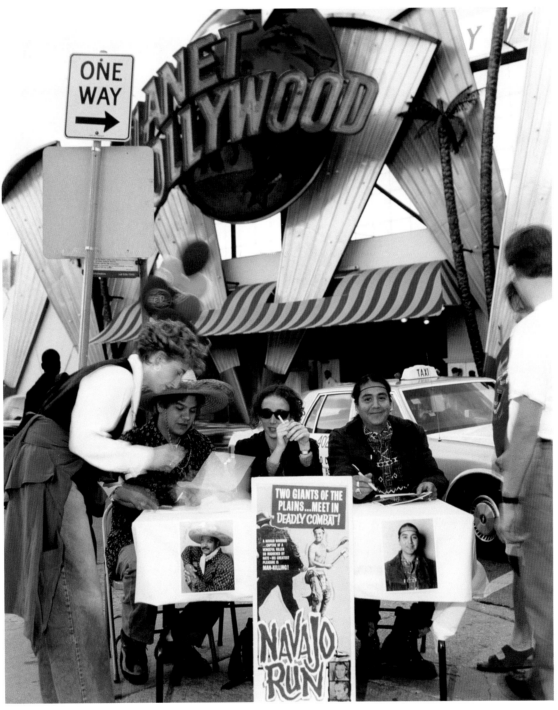

"Pancho y Tonto on the Trail"

ROBERT C. BUITRÓN

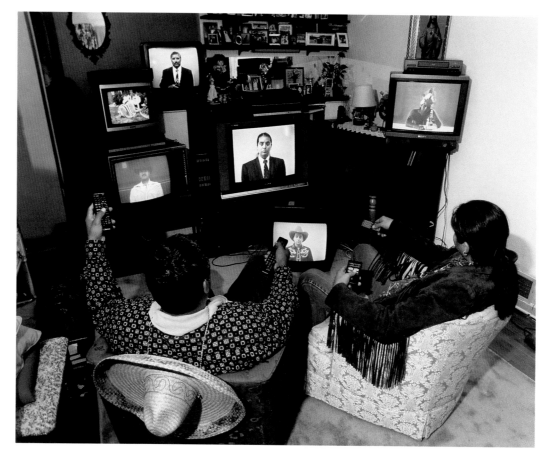

"Identity Surfing"

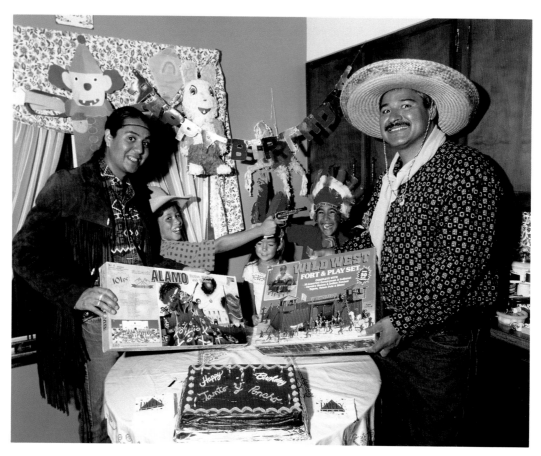

"Pancho y Tonto Exchange Birthday Gifts"

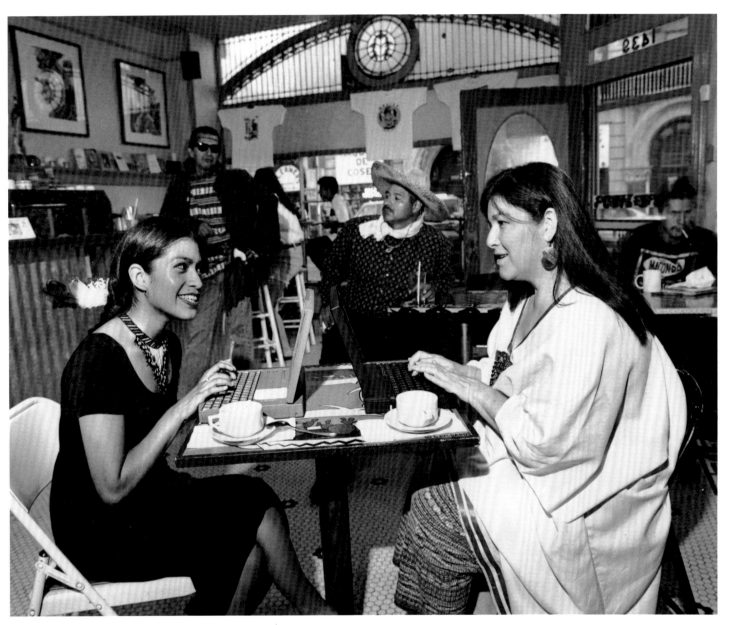

"Malinche y Pocahontas chismeando con Powerbooks"

ROBERT C. BUITRÓN

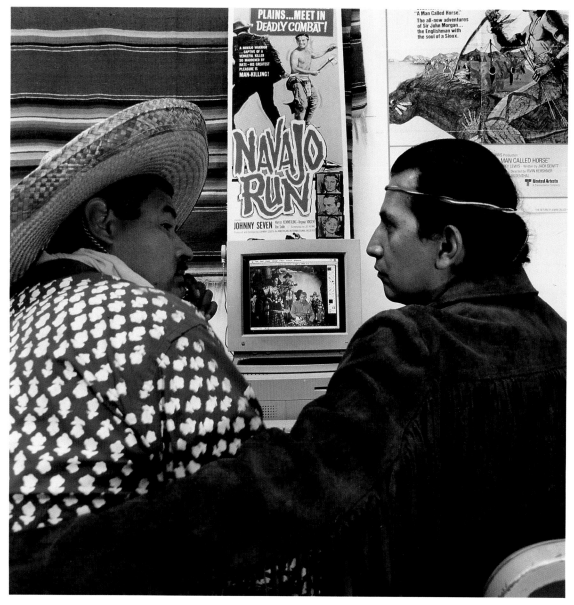

"T.P. Broadcasting Colorizes *Stagecoach*"

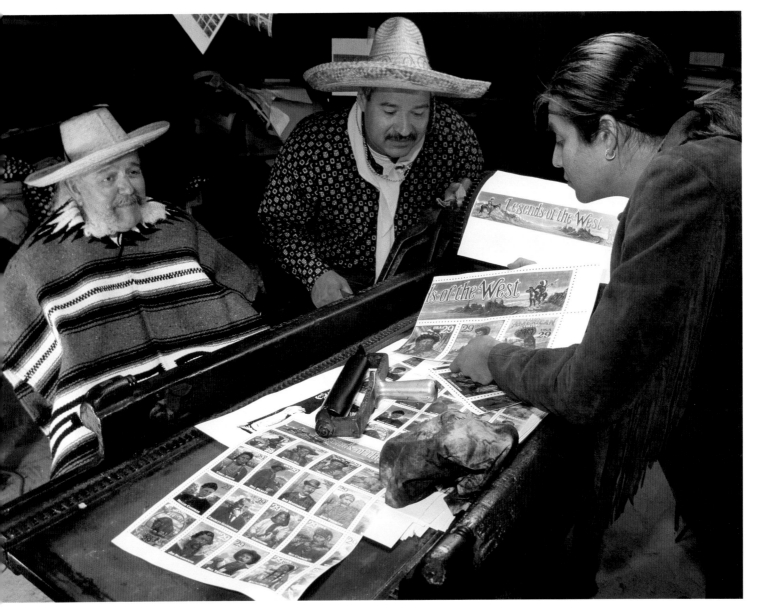

"T.P. Grafix Ponders Missing 'Legends of the West' Postage Stamp"

ROBERT C. BUITRÓN

María's Great Expedition

CHRISTINA FERNANDEZ

In 1910, María left the ranch she lived on with her family near Morelia, Michoacan, Mexico. She was fourteen. Thousands of others, mainly single men and men with families, left the central plateau that year; the Revolution had begun and jobs in the mines and on the railways were scarce. The *Porfiriato* or Díaz dictatorship, which nationalized communal lands and accorded it to foreign (including United States) interests, had forced many small farmers off their land to look for work. Between 1910 and 1920, over one million Mexicans would leave the central plateau of Mexico and head north into the recently expropriated American Southwest. This migration provided a much-needed source of labor for the burgeoning industries of the Southwest — railways, mines, agriculture.

The main entry point into the U.S. from Mexico at that time was El Paso, Texas. María's first husband had established a cantina in Juárez, Mexico, just across the border from El Paso. María joined him there in 1911. While living in Juárez she sometimes crossed into El Paso to work cleaning houses. In Juárez, María gave birth to her first son and became pregnant with a second. After three years in Juárez, she gathered her things, picked up her child, and left

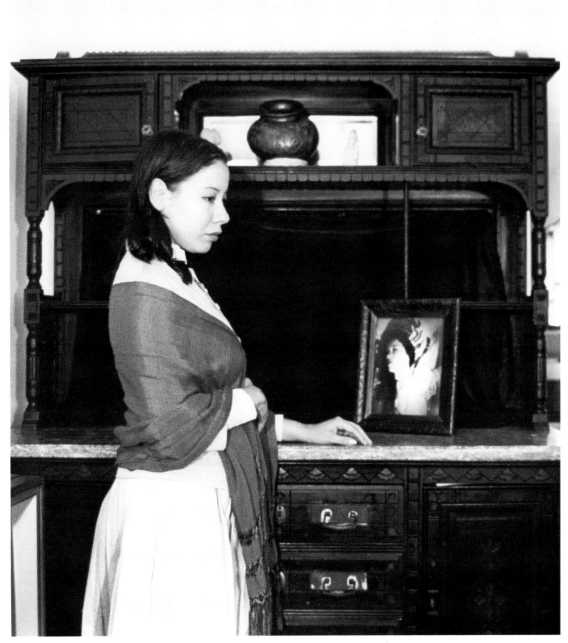

"1910, Leaving Morelia, Michoacan, Mexico"

CHRISTINA FERNANDEZ

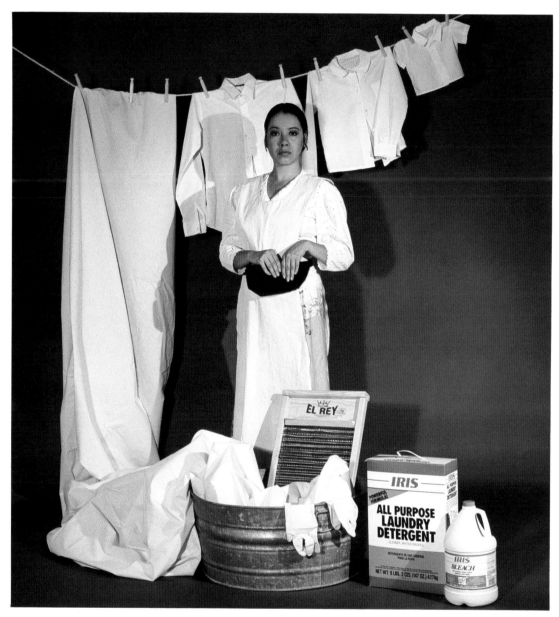

"1919, Portland, Colorado"

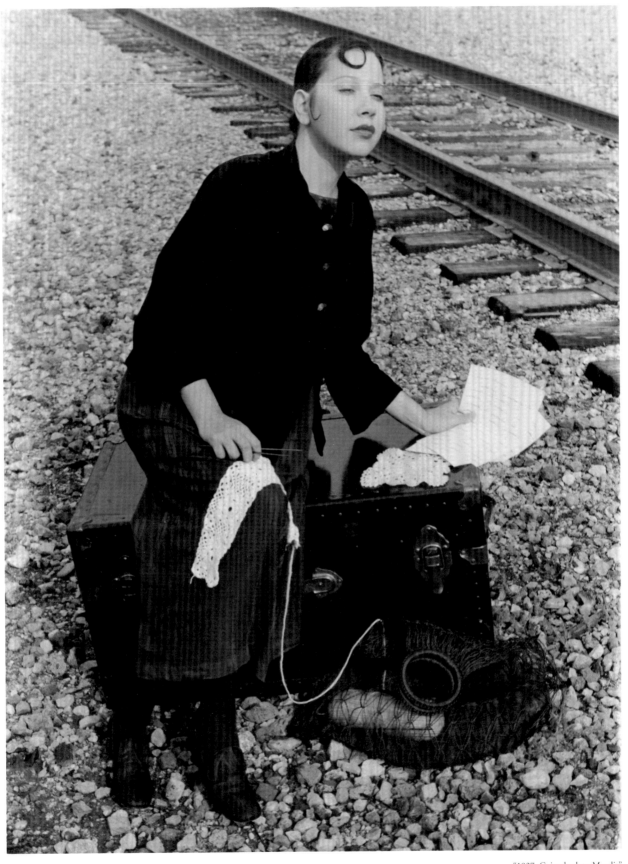

"1927, Going back to Morelia"

CHRISTINA FERNANDEZ

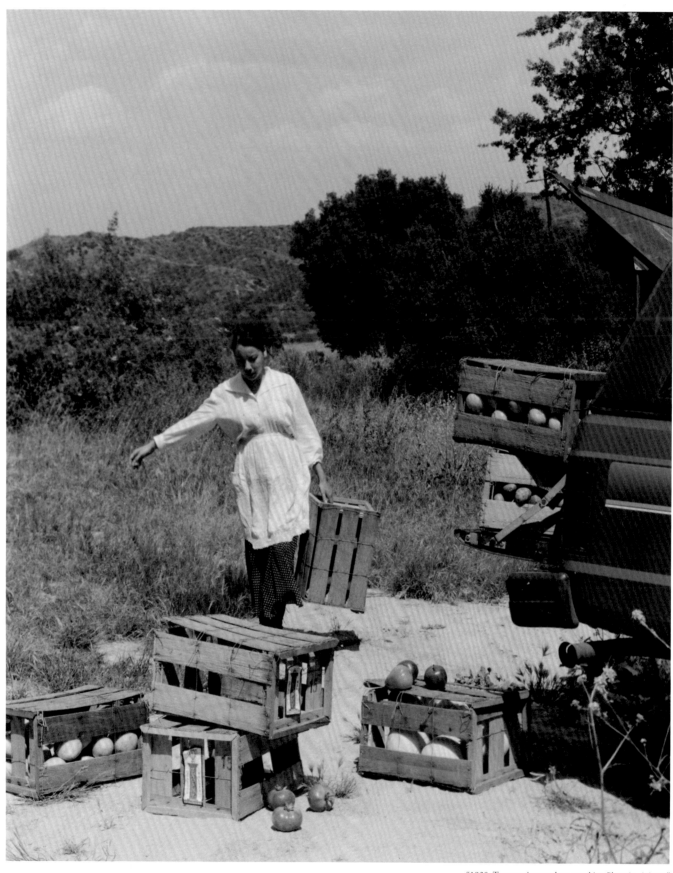

"1930, Transporting produce, outskirts Phoenix, Arizona"

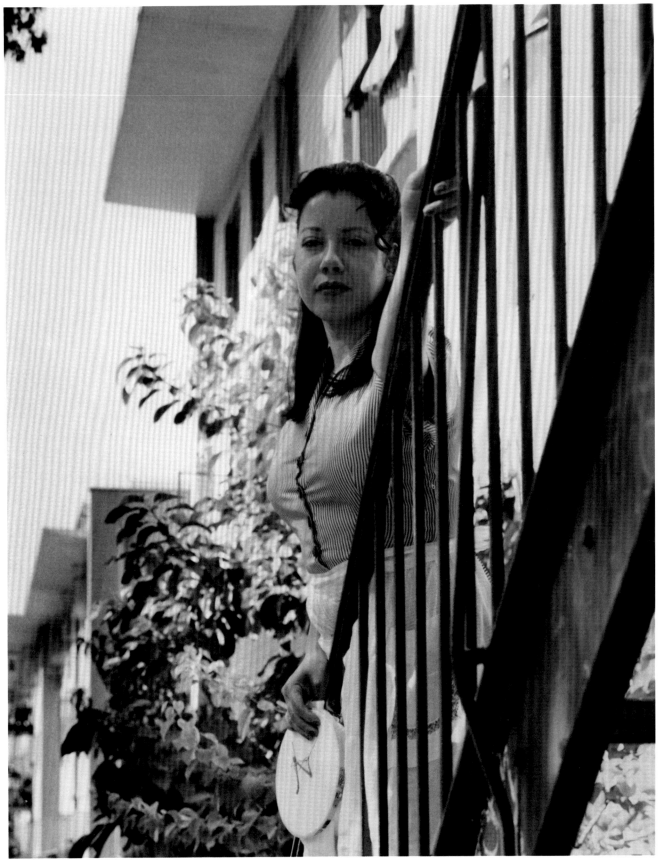

"1945, Aliso Village, Boyle Heights, California"

CHRISTINA FERNANDEZ

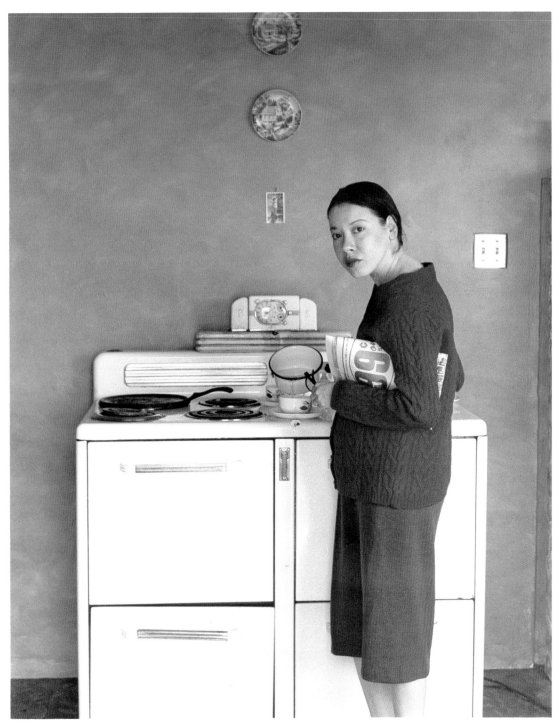

"1950, San Diego, California"

CHRISTINA FERNANDEZ

Social Unwest

HARRY GAMBOA, JR.

My six-shooter fires emotional blanks as the dominant culture encircles their undercover wagons. Heads roll in disbelief across the urbanscape like concrete tumble-weeds that go crash on the freeway. We are branded with an indelible sizzle. Our burning flesh is the fragrance of a society that erases all traces of foreshadow from our background. The images in *Social Unwest* depict the anti-historical events of lives that contradict the notion that the West was won. Stagnant smog, impermanent graffiti, lapses of angst, and the impulse toward random revolution are illuminated in the final awareness that negative/positive will fade from memory.

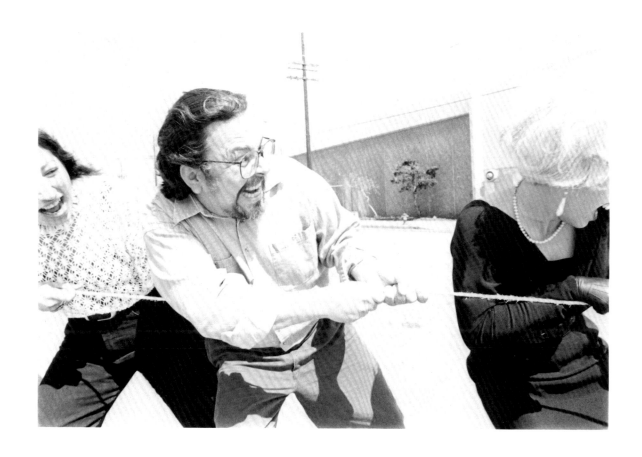

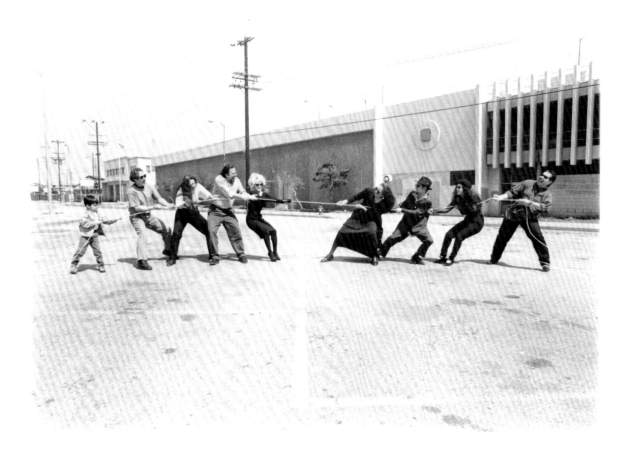

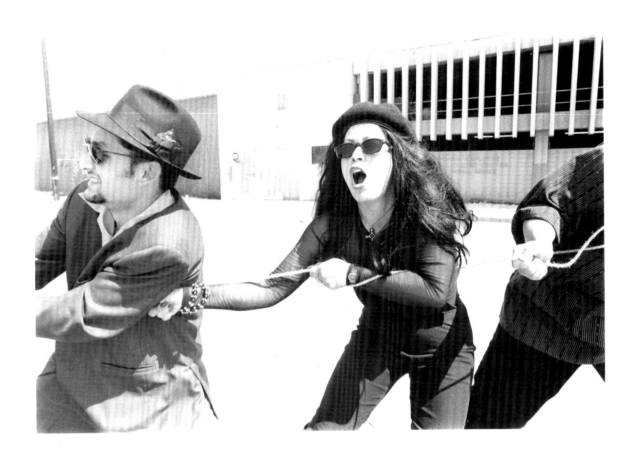

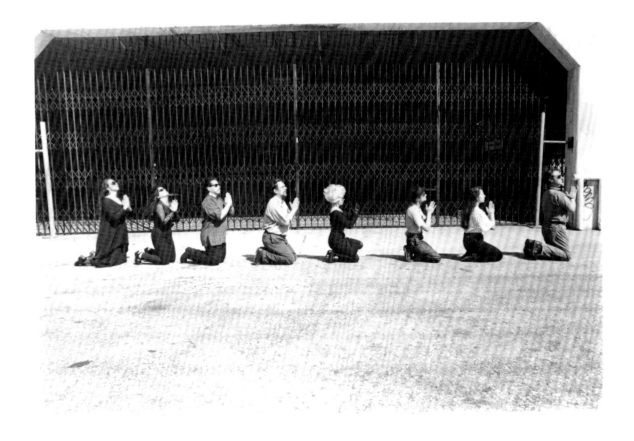

HARRY GAMBOA, JR.

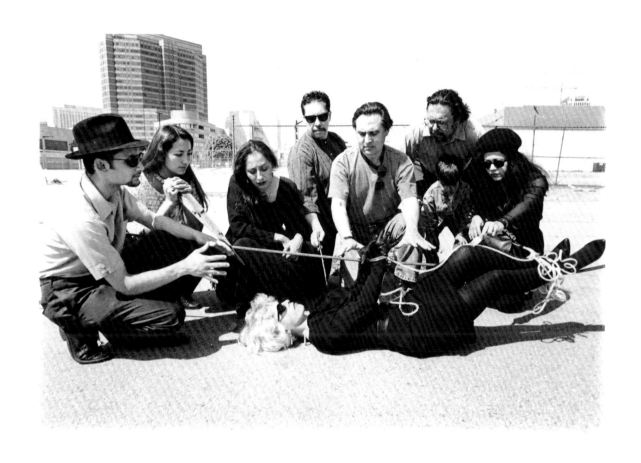

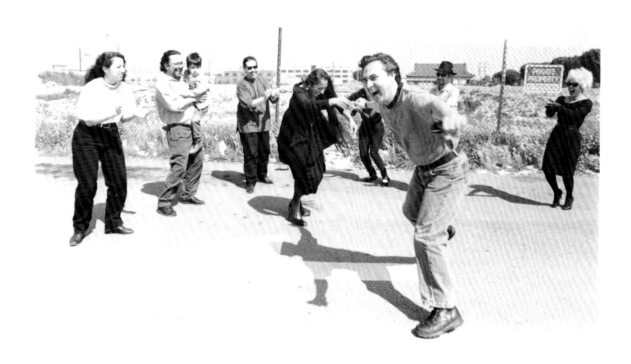

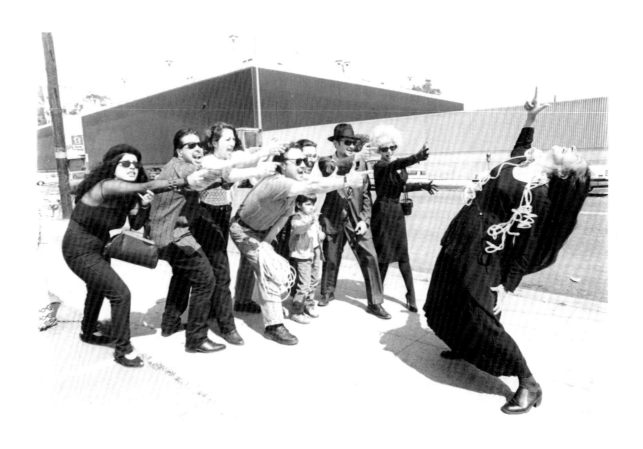

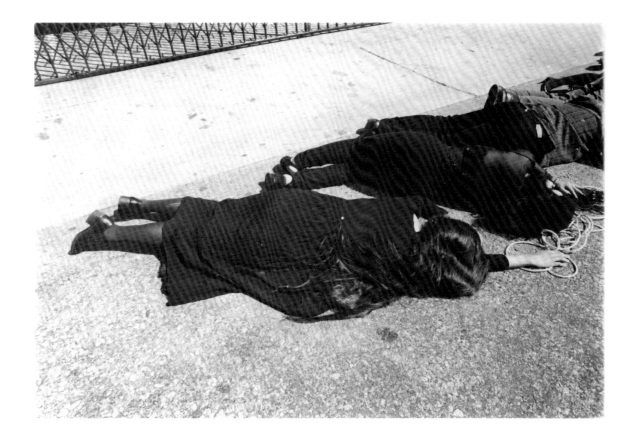

HARRY GAMBOA, JR.

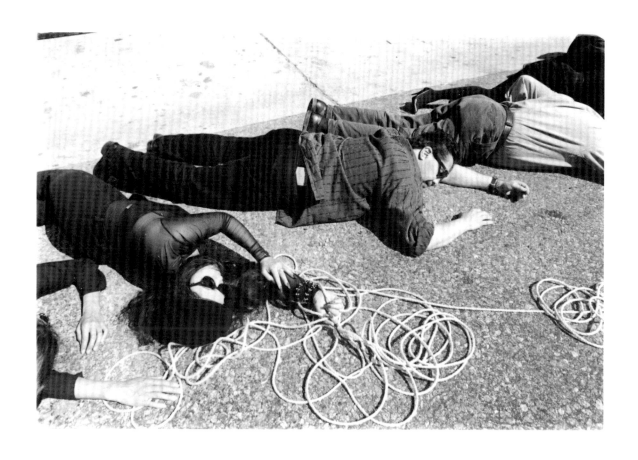

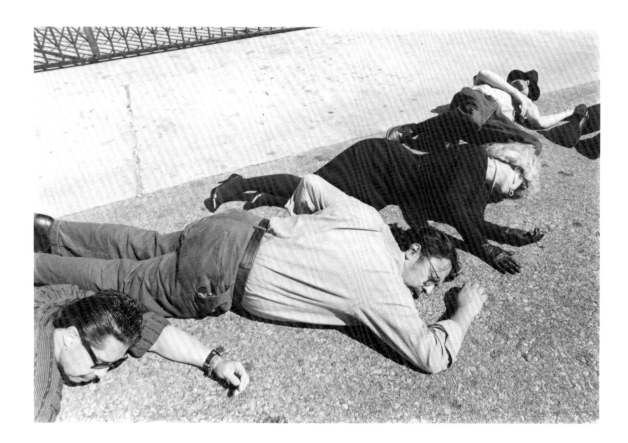

FROM THE WEST

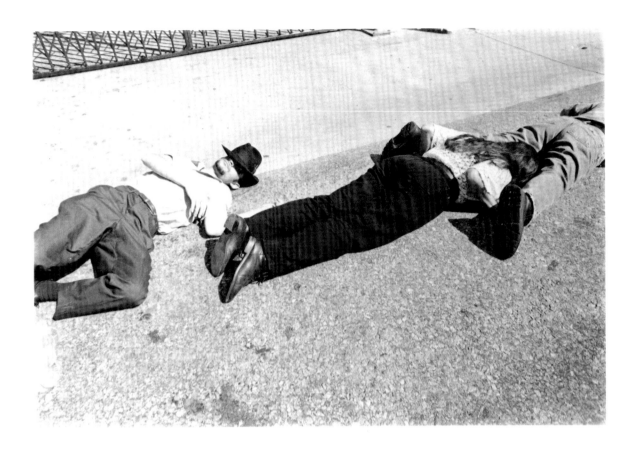

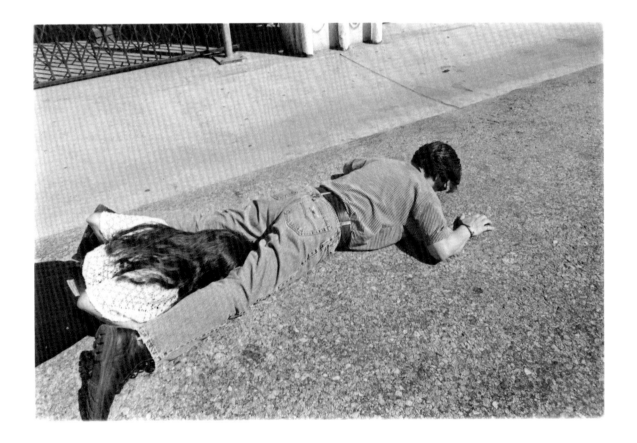

HARRY GAMBOA, JR.

Los Comanches

MIGUEL GANDERT

Llano. Talpa. Ranchos de Taos. The first sun of the New Year rises to the beating of drums. Hispano Comanche dancers enter the famed Santuario de San Francisco de Asís to pray. So begins the feast of Emmanuel in the *Nuevomexicano* villages, the celebration of a holy promise fulfilled. Divinity and humanity become one, so the people dance. Like their neighbors at Taos Pueblo, the *gente* in these villages dress in buckskin and feathers and sing their oldest songs in tribute to their indigenous, *mestizo* heritage. From house to house they dance to honor Manueles and Manuelas, the namesakes of Emmanuel, on this blessed day.

Two days after Christmas, dust, thundering hooves, and battle cries are raised in Alcalde, a village south of Taos. *Los Comanches,* a folk play dating to the 1780s, celebrates the heroic struggle between Españoles and Comanches. The death of the great chief Cuerno Verde marks the end of generations of violence and the beginning of a lasting alliance. The spirit of Comanche culture is honored here as *Nuevomexicano* villagers reenact the terms of their own survival and cultural origins.

Indo-Hispano music, dance, and celebrations have been handed down for generations in northern New Mexico. Despite this lengthy heritage, there is slight mention of these traditions in the historical and anthropological record. In the Anglo-American imagination, miscegenation is equated with contamination. When Edward S. Curtis passed through New Mexico staging his portraits of the American Indian, he bypassed these *mestizo* communities. In his vision of the Noble Savage, there was simply no room for their ignoble Hispanicized brethren.

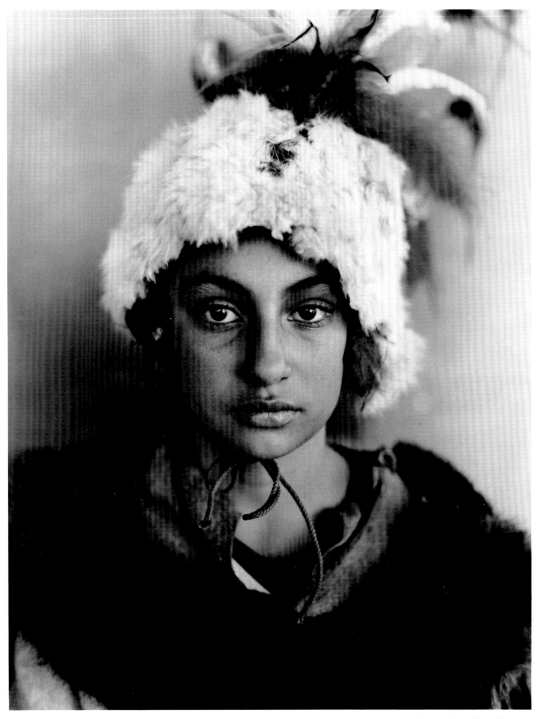

Laura Aguilera, Talpa, NM, 1995

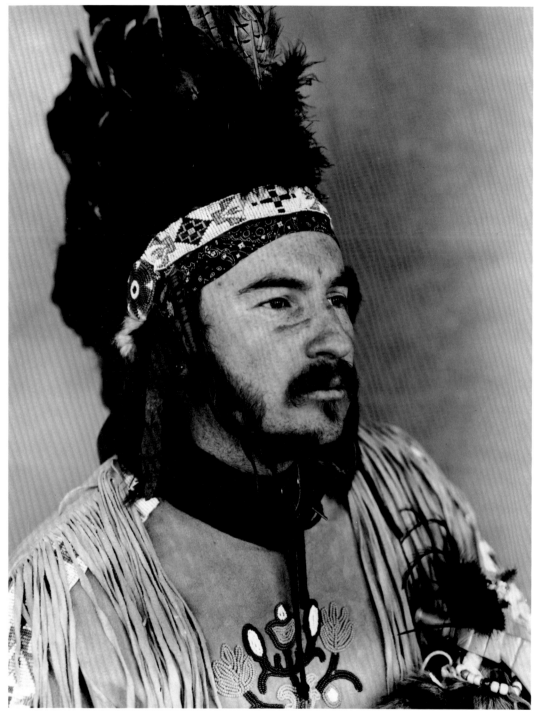

Luis Marcos Girón, Talpa, NM, 1995

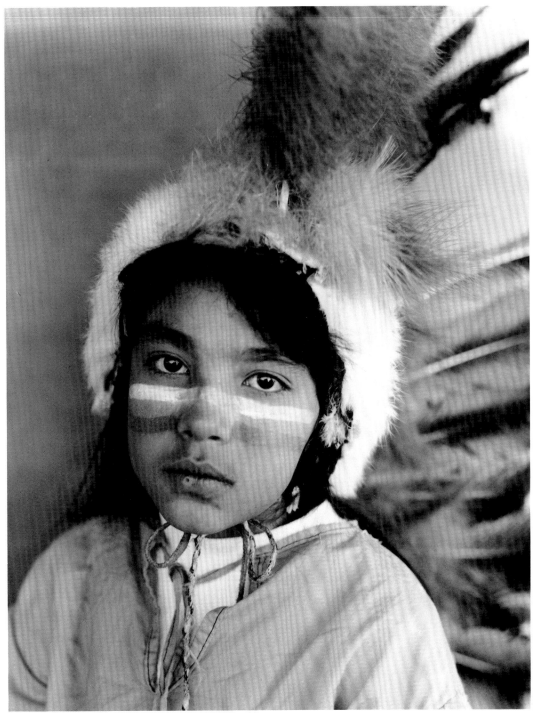

Tanya Trujillo, Talpa, NM, 1995

MIGUEL GANDERT

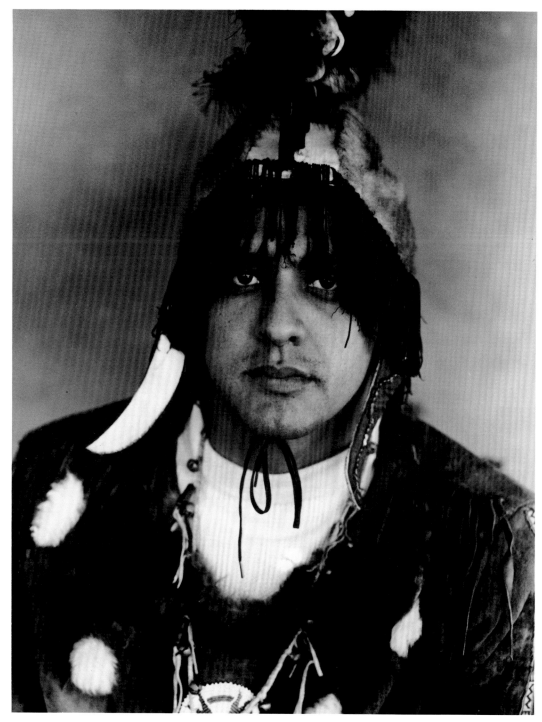

Estevan Gonzales, Talpa, NM, 1995

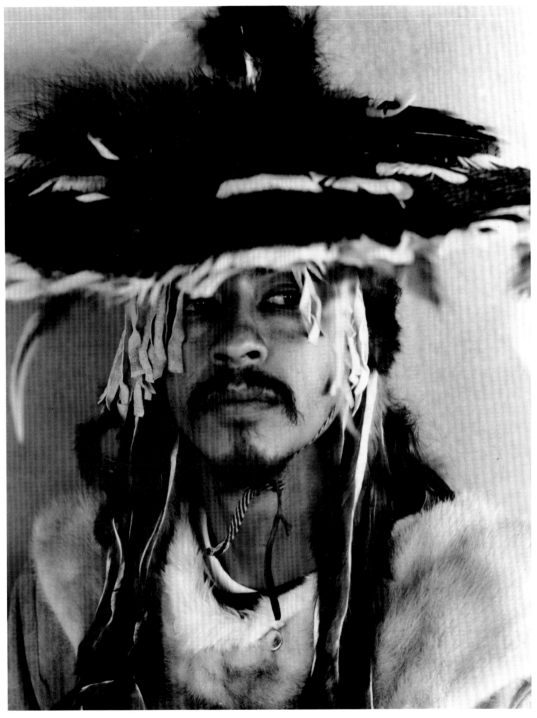

David Gonzales, Talpa, NM, 1995

MIGUEL GANDERT

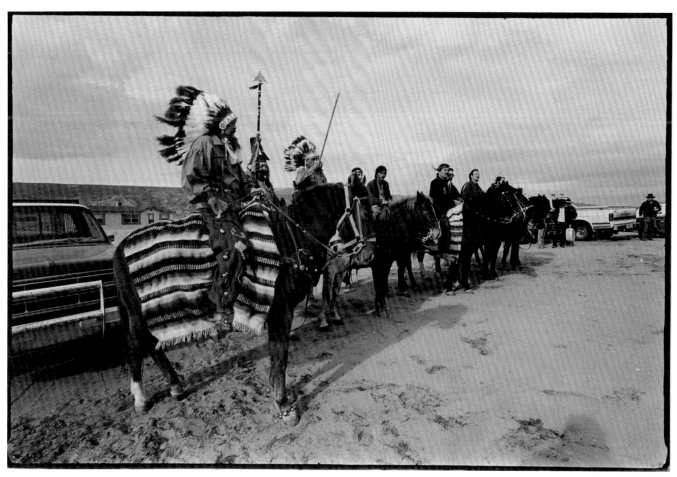

Los Comanches, Alcalde, NM, 1993

54

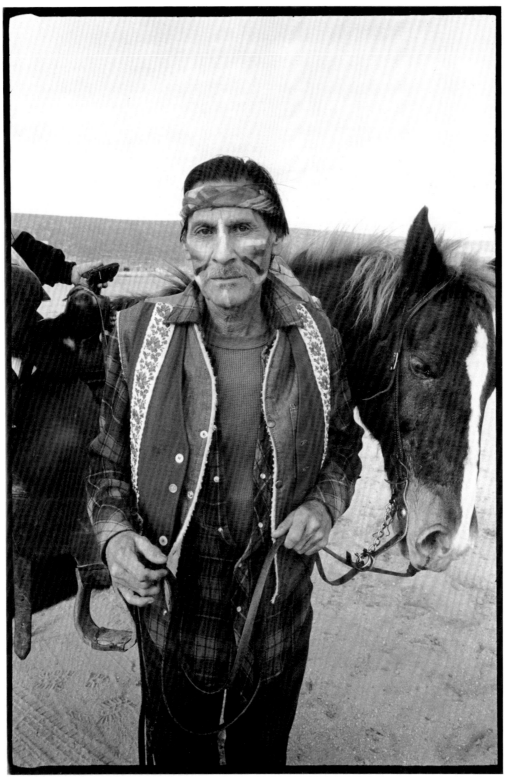

El Comanche, Galento Martinez, Alcalde, NM, 1993

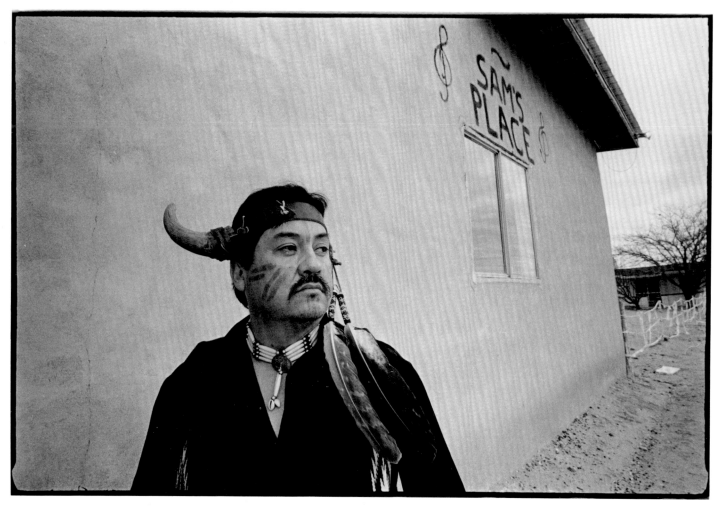

Cuerno Verde, Arsenio Martinez, Alcalde, NM, 1993

FROM THE WEST

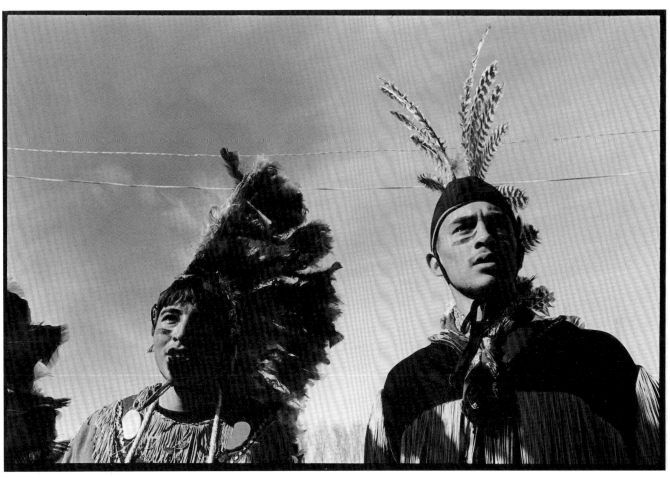

Comanches, Talpa, NM, 1995

MIGUEL GANDERT

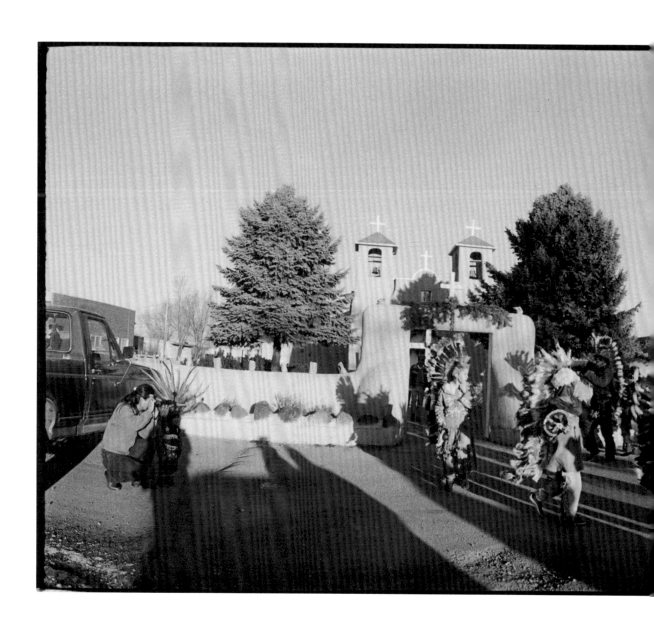

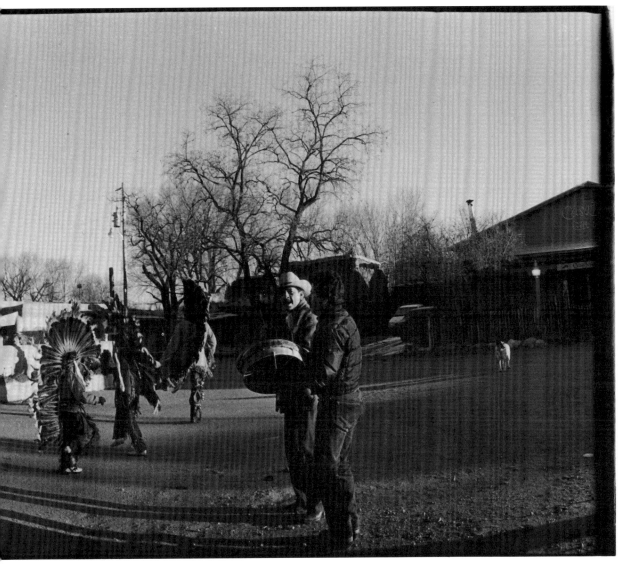

Baile Redondo, Rancho de Taos, NM, 1995

MIGUEL GANDERT

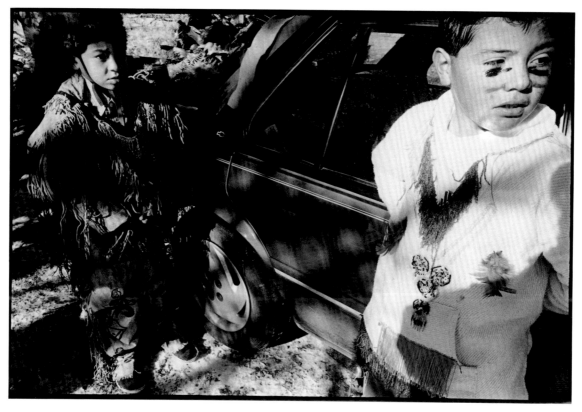

Comanchitos, Talpa, NM, 1995

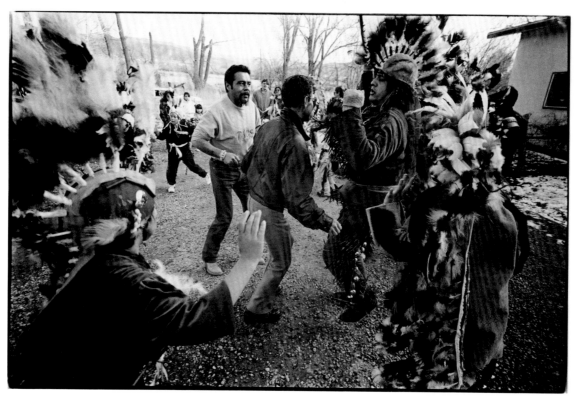

Los Cautivos, Talpa, NM, 1995

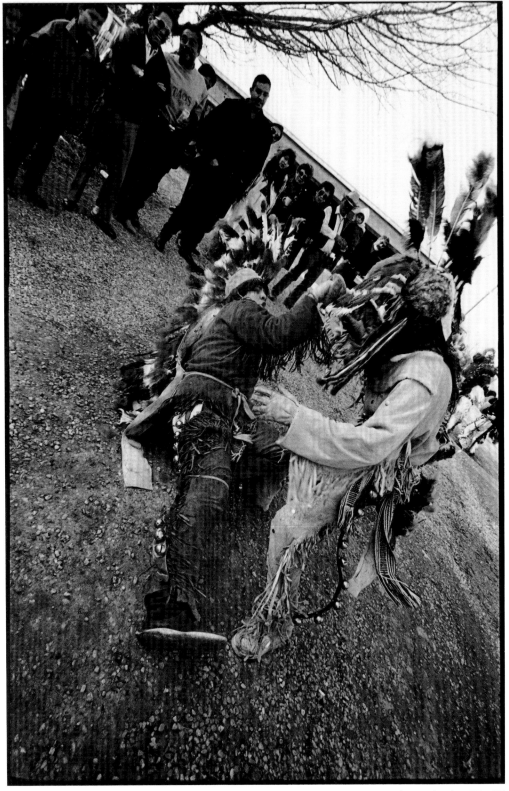

El Espantado, Talpa, NM, 1995

61

Shooting the Tourist

DELILAH MONTOYA

Before photographically shooting the tourist, I conceived the West not as part of my heritage but more as a construct of western civilization. The West is west because it is the most westerly point from Ancient Rome as well as the point before one leaps back into the east. But in watching from the perspective of Aztlán, another mythical orientation, western man comes to the West by way of the east seeking non-western culture. In an orbiting round world, locating the West really gets confusing.

In this series, I attempt to redirect documentary photography away from primitive, lower class and peasant societies — the stuff of the West — and gaze at the industry that contributed to the West's mythic creation — tourism. I photographed tourists in the styles of Weegee and Diane Arbus — a kind of street photography with an edge. But could I, as a self-proclaimed outsider, "truthfully" depict the activities of the tourist, or would I have to go native? Ultimately, the whole business began to feel like some sort of surreal activity involving a narcissistic alienation. But after shooting the tourist from different westerly regions and bringing their images home, one fact became apparent: tourists everywhere do the same things, participate in the same stories. In utilizing the very elements that define tourist activity, each series of accordion-fold postcards tells one such story.

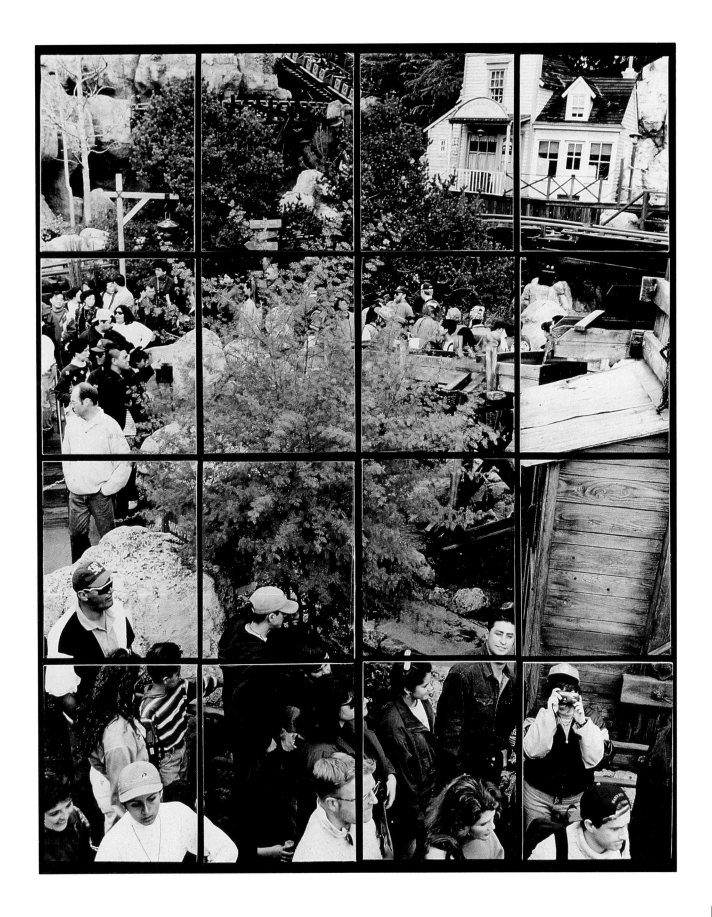

LOOKING

4

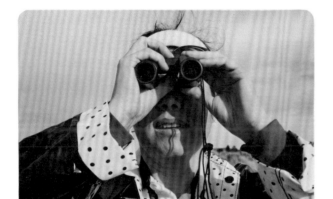

1

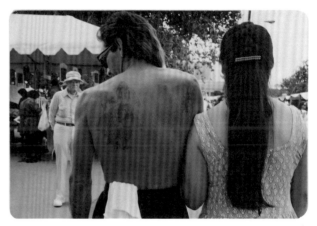

5

2

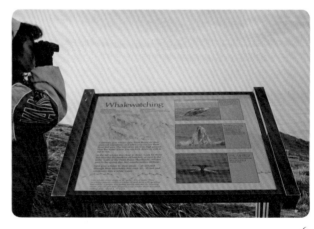

6

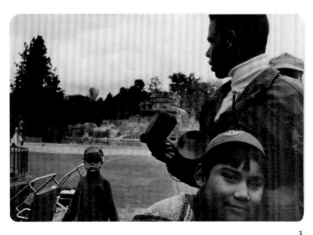

3

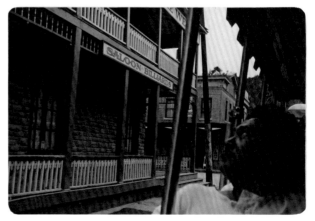

7

IMAGING

4

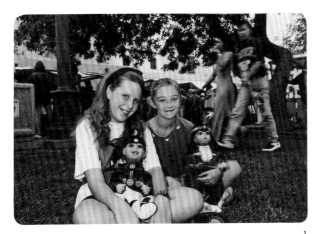

1

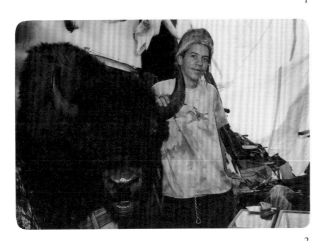

5

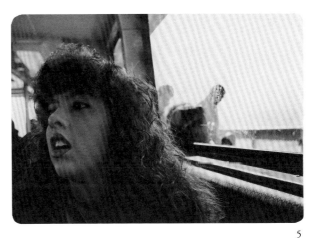

2

6

3

7

65

DELILAH MONTOYA

STAGING

4

1

5

2

6

3

7

COLLECTING

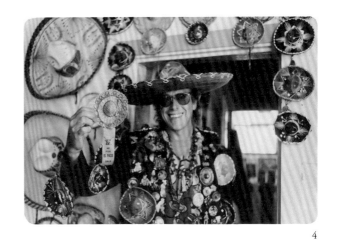

4

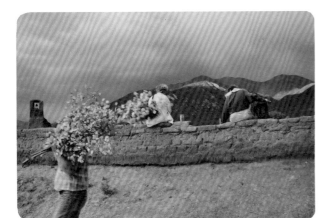

1

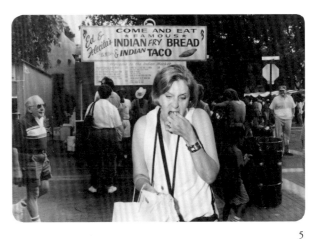

5

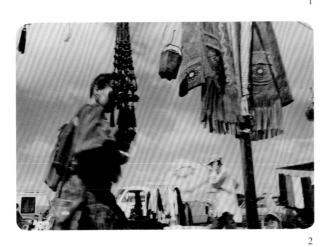

2

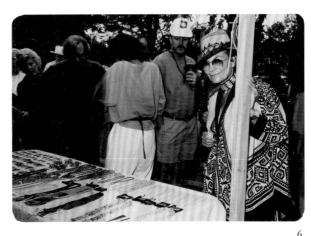

6

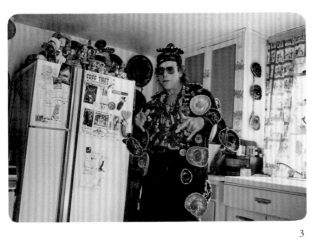

3

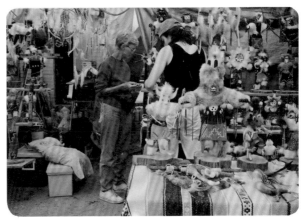

7

DELILAH MONTOYA

GOING
NATIVE

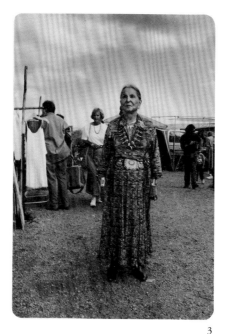

3

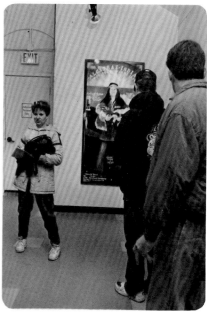

6

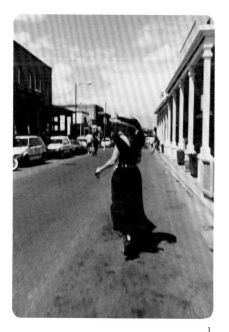

1

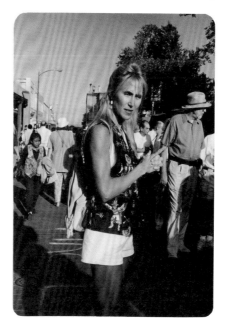

4

7

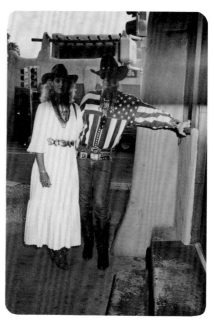

2

5

PRESERVING

4

1

5

2

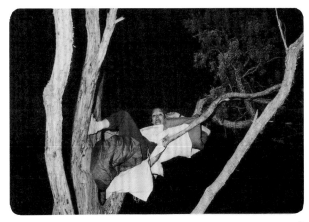

6

3

7

SYNCRETIZING

4

1

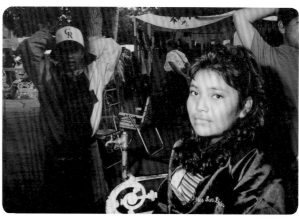

5

2

6

3

7

My Alamo

KATHY VARGAS

This series is about my (usually) ambiguous relationship to and with the Alamo. Living all my life in San Antonio, Texas, and being both Chicana and Tejana, I have negotiated that relationship for what seems like an incredibly long time. Even before I was born, the Alamo figured in family history and identity. That issue of history and identity and my anxious relationship to the Alamo are tied up in questions like, "Which side was your family on?" (Neither.) "Are you a Mexican or a Texan?" (Both — and more.) "How do you like my 'coon skin hat?" (Are you sure it's dead?)

Some of my recollections of the Alamo are humorous; some are serious. Most of them have a bite, but it's a bite that I did not invent. It's a bite that recurs in the inherent aggression and often in the racism that is part and parcel of standing before war monuments and thinking oneself to be on one side or another, either by choice or because history gives us no choice. Trying to think of myself as victor or vanquished in relationship to the Alamo, I couldn't come up with a concrete conclusion — hence my ambiguity. However, events at the Alamo within the last five or six years have allowed me to see it all in a new light. Now the whole Alamo reality is much less burdensome, much more humorous. Thanks for that, Ozzy. But I'm getting ahead of myself; that's what this series is all about.

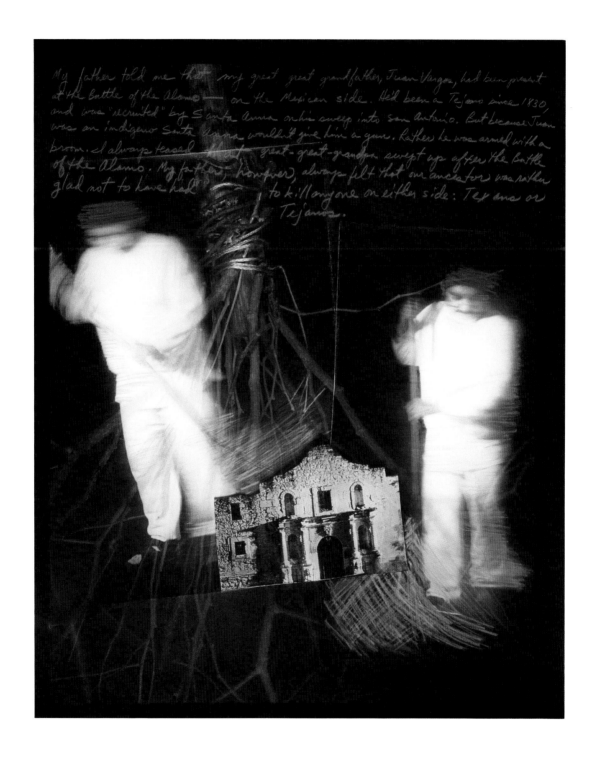

My father told me that my great great grandfather, Juan Vargas, had been present at the Battle of the Alamo — on the Mexican side. He'd been a Tejano since 1830, and was "recruited" by Santa Anna on his sweep into San Antonio. But because Juan was an indigeno Santa Anna wouldn't give him a gun. Rather he was armed with a broom. I always teased ... great-great-grandpa swept up after the Battle of the Alamo. My father, however, always felt that our ancestor was rather glad not to have had ... to kill anyone on either side: Texans or Tejanos.

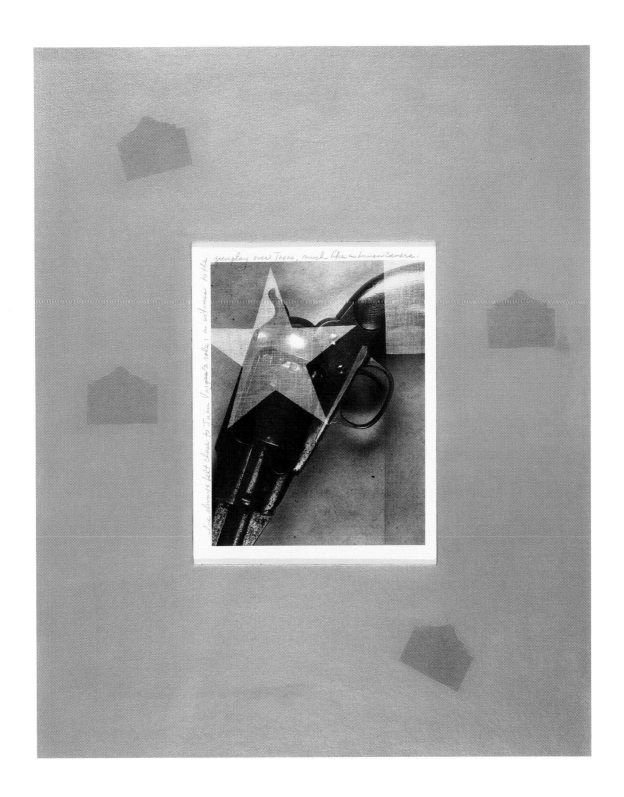

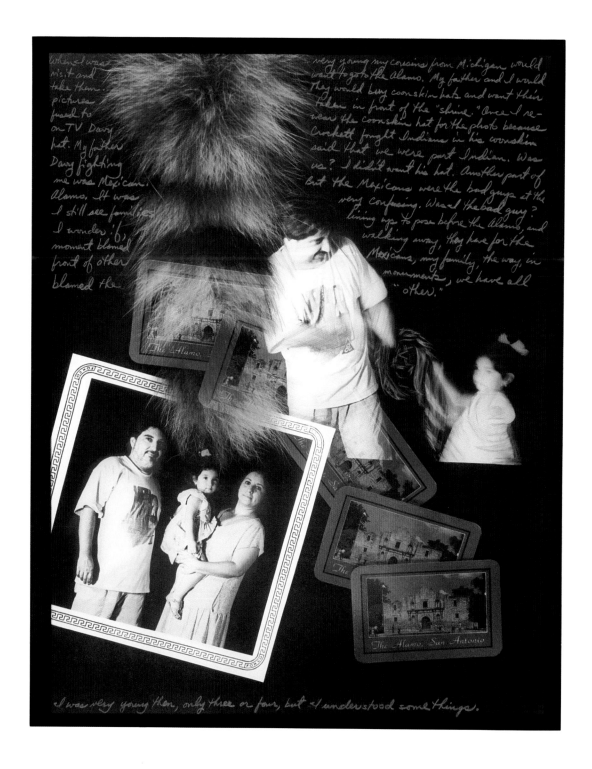

When I was ... very young my cousins from Michigan would visit and ... want to go to the Alamo. My father and I would take them ... They would buy coonskin hats and want their pictures ... taken in front of the "shrine." Once I re-used to ... wear the coonskin hat for the photo because on TV Davy ... Crockett fought Indians in his coonskin hat. My father ... said that we were part Indian. Was Davy fighting ... us? I didn't want his hat. Another part of me was Mexican. ... But the Mexicans were the bad guys at the Alamo. It was ... very confusing. Was I the bad guy? I still see families ... lining up to pose before the Alamo, and I wonder if, ... walking away, they have for the moment blamed ... Mexicans, my family, the way, in front of other ... monuments, we have all blamed the ... "other."

I was very young then, only three or four, but I understood some things.

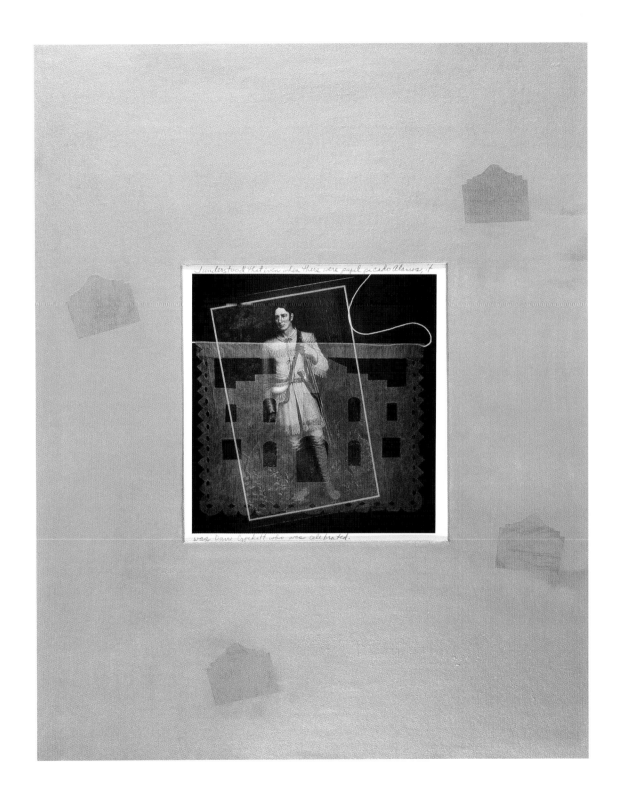

I understood that even when there were papel picado Alamos, it

was Davy Crockett who was celebrated.

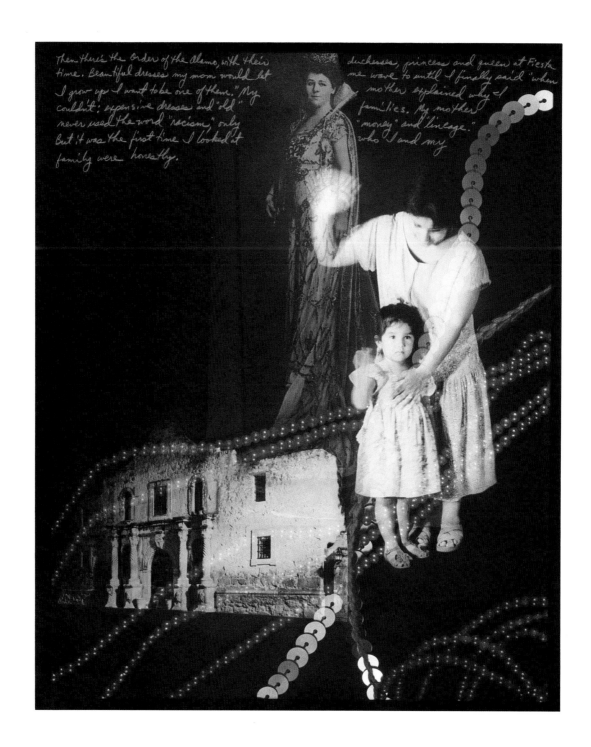

Then there's the Order of the Alamo, with their duchesses, princess and queen at Fiesta time. Beautiful dresses my mom would let me wave to until I finally said "when I grow up I want to be one of them." My mother explained why I couldn't: expensive dresses and "old" families. My mother never used the word "racism," only "money" and "lineage." But it was the first time I looked at who I and my family were honestly.

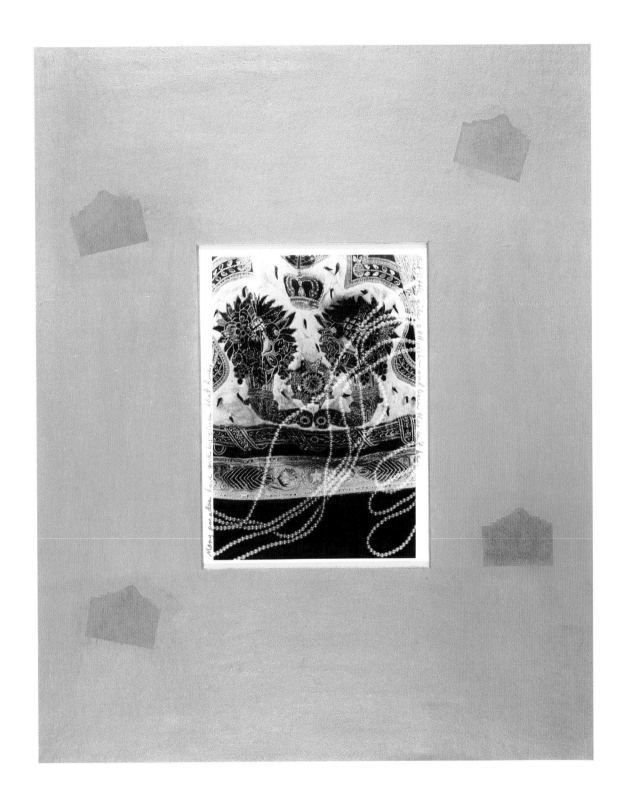

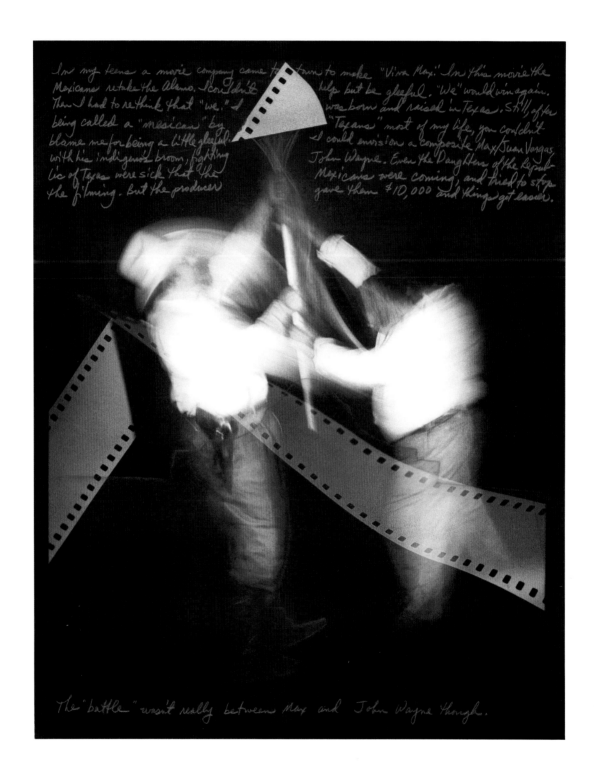

In my teens a movie company came to town to make "Viva Max." In this movie the Mexicans retake the Alamo. I couldn't help but be gleeful. "We" would win again. Then I had to rethink that "we." After being called a "mesican" by "Texans" most of my life, you couldn't blame me for being a little gleeful. I could envision a composite Max/Juan Vargas, with his indigenous broom, fighting John Wayne. Even the Daughters of the Republic of Texas were sick that he Mexicans were coming, and tried to stop the filming. But the producer gave them $10,000 and things got easier.

The "battle" wasn't really between Max and John Wayne though.

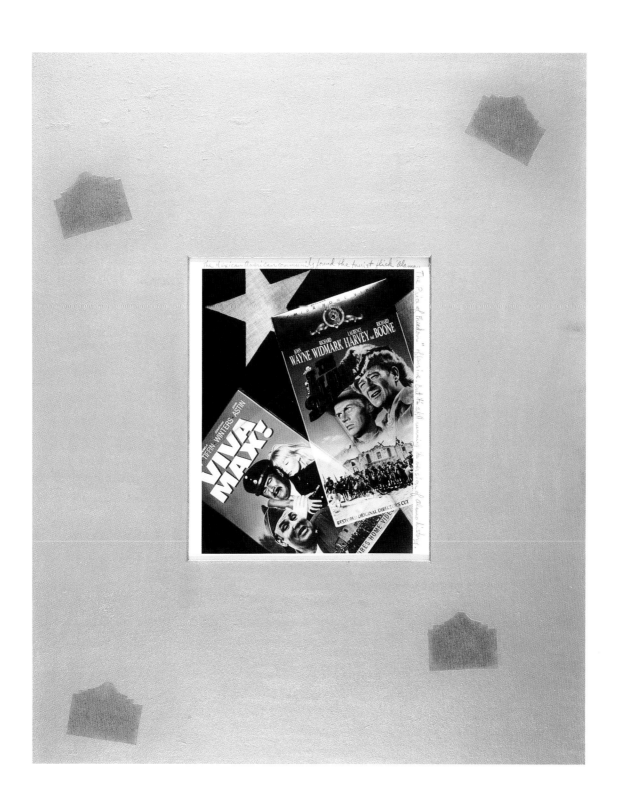

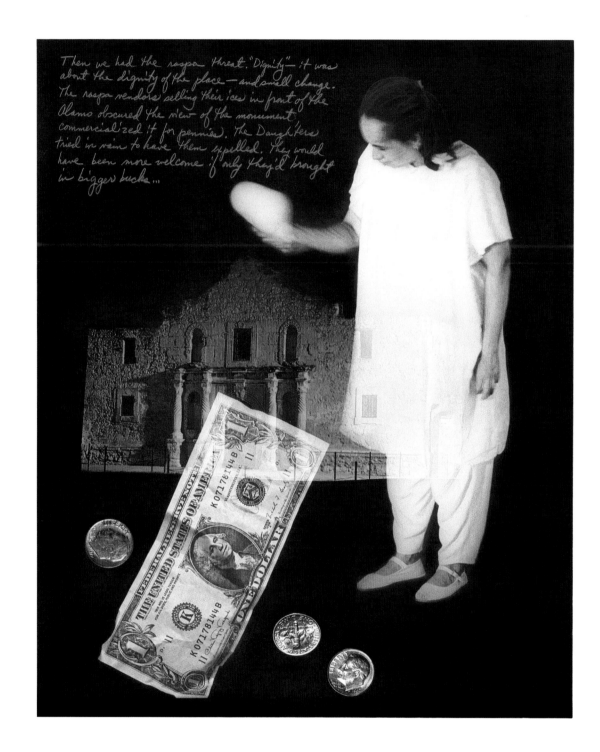

Then we had the raspa threat. "Dignity"— it was about the dignity of the place—and small change. The raspa vendors selling their ices in front of the Alamo obscured the view of the monument, commercialized it for pennies. The Daughters tried in vain to have them expelled. They would have been more welcome if only they'd brought in bigger bucks...

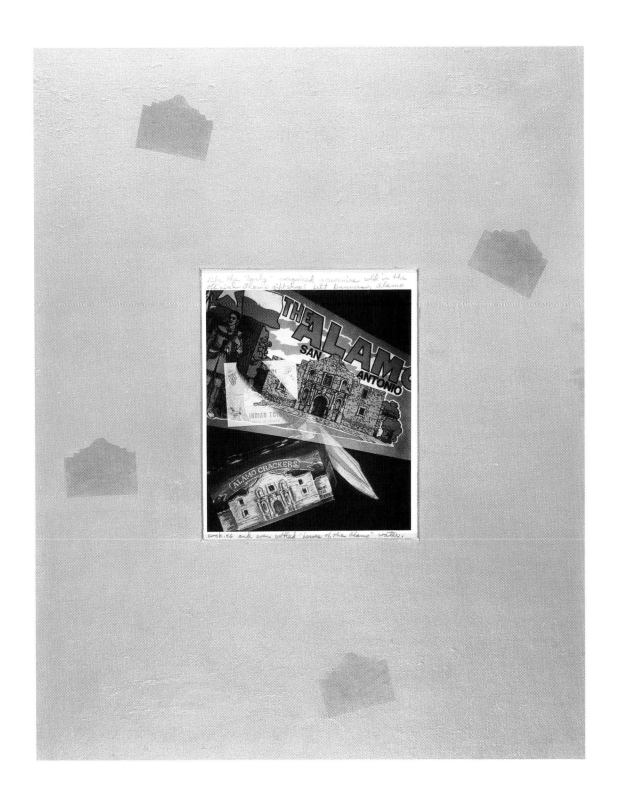

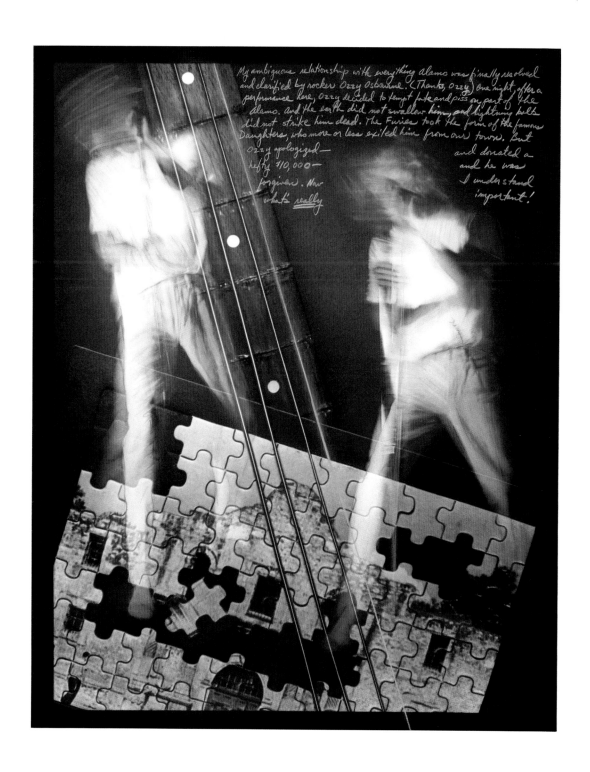

My ambiguous relationship with everything Alamo was finally resolved and clarified by rocker Ozzy Osbourne. (Thanks, Ozzy.) One night, after a performance here, Ozzy decided to tempt fate and piss on part of the Alamo. And the earth did not swallow him, and lightning bolts did not strike him dead. The Furies took the form of the famous Daughters, who more or less exiled him from our town. But Ozzy apologized— hefty $10,000— forgiven. Now what's really and donated a and he was I understand important!

If only Santa Anna had known what the going price was! Maybe we Tejanos wouldn't have been "mexicans" all these years.

KATHY VARGAS

CHECKLIST OF THE EXHIBITION

Height precedes width

ROBERT C. BUITRÓN

El Corrido de Happy Trails (starring Pancho y Tonto), 1995

"Pancho Asks Tonto if He's más indio que español"
Black and white silver gelatin print
16 x 20 in.

"Seeking Indians—Mexicans Need Not Apply"
Black and white silver gelatin print
16 x 20 in.

"Pancho y Tonto on the Trail"
Color print
20 x 16 in.

"Identity Surfing"
Color print
16 x 20 in.

"Pancho y Tonto Exchange Birthday Gifts"
Color print
16 x 20 in.

"Malinche y Pocahontas chismeando con Powerbooks"
Black and white silver gelatin print
16 x 20 in.

"T.P. Broadcasting Colorizes *Stagecoach*"
Color print
20 x 16 in.

"T.P. Grafix Ponders Missing 'Legends of the West' Postage Stamp"
Color print
20 x 16 in.

Performers: José Buitrón, Anthony Castañeda, Carlos Cortez, Lydia Mendoza Huantes, Jeff Abbey Maldonado, Sara Peak, César Sánchez, Susana Sandoval, Encarnación Turuel, and Marie Walz.

CHRISTINA FERNANDEZ

María's Great Expedition, 1995

Untitled (not illustrated)
Photocollage
30 x 40 in.

"1910, Leaving Morelia, Michoacan, Mexico"
Black and white silver gelatin print, sepia toned
20 x 16 in.

"1919, Portland, Colorado"
Black and white silver gelatin print, sepia toned
20 x 16 in.

"1927, Going back to Morelia"
Black and white silver gelatin print
20 x 16 in.

"1930, Transporting produce, outskirts Phoenix, Arizona"
Black and white silver gelatin print
20 x 16 in.

"1945, Aliso Village, Boyle Heights, California"
Black and white silver gelatin print
20 x 16 in.

"1950, San Diego, California"
Color print
20 x 16 in.

HARRY GAMBOA, JR.

Social Unwest, 1995

Twelve black and white silver gelatin prints (Printing by Willie García)
16 x 20 in.

Nine black and white photocopies, double-sided, text and image
11 x 8.5 in.

Performers: Max Benavidez, Diane Gamboa, Linda Gamboa, Willie García, Ricardo Gonzalves, Monica Sahagún, Paulina Sahagún, Carlo Valadez, and John Valadez

MIGUEL GANDERT

Los Comanches, 1993-95

Laura Aguilera, Talpa, NM, 1995
Black and white silver gelatin print
20 x 16 in.

Luis Marcos Girón, Talpa, NM, 1995
Black and white silver gelatin print
20 x 16 in.

Tanya Trujillo, Talpa, NM, 1995
Black and white silver gelatin print
20 x 16 in.

Estevan Gonzales, Talpa, NM, 1995
Black and white silver gelatin print
20 x 16 in.

David Gonzales, Talpa, NM, 1995
Black and white silver gelatin print
20 x 16 in.

Los Comanches, Alcalde, NM, 1993
Black and white silver gelatin print
16 x 20 in.

El Comanche, Galento Martínez, Alcalde, NM, 1993
Black and white silver gelatin print
20 x 16 in.

Cuerno Verde, Arsenio Martínez, Alcalde, NM, 1993

Black and white silver gelatin print
16 x 20 in.

Comanches, Talpa, NM, 1995
Black and white silver gelatin print
16 x 20 in.

Baile Redondo, Rancho de Taos, NM, 1995
Black and white silver gelatin print
8 x 24 in.

Comanchitos, Talpa, NM, 1995
Black and white silver gelatin print
16 x 20 in.

Los Cautivos, Talpa, NM, 1995
Black and white silver gelatin print
16 x 20 in.

El Espantado, Talpa, NM, 1995
Black and white silver gelatin print
20 x 16 in.

The pictures in this series were made with the support of the Center for Regional Studies at the University of New Mexico.

DELILAH MONTOYA

Shooting the Tourist, 1995

Untitled photo mural
Black and white silver gelatin prints with sepia tone
Sixteen segments, each 24 x 20 in.

Postcard series:
"Looking" (t-b)
"Imaging" (l-r)
"Staging" (l-r)
"Collecting" (t-b)
"Going Native" (l-r)
"Preserving" (l-r)
"Syncretizing" (t-b)
Sepia toned postcards
Seven images per series, each 4 x 6 in.
(orientation of series in parenthesis)

KATHY VARGAS

My Alamo, 1995

Six pairs of hand-colored photographs
(1a, 1b-6a, 6b)
a: hand-colored silver gelatin print
20 x 16 in.
b: mixed media with hand-colored silver gelatin print (10 x 8 in.)
20 x 16 in.

All works in the exhibit were commissioned by The Mexican Museum and are in the Museum's permanent collection.

EXHIBITION ARTISTS

Robert C. Buitrón (Chicago and Phoenix) is a founding artist of Movimiento Artistico del Rio Salado (MARS), an artist-run arts organization in Phoenix, Arizona, established in 1978. In 1994, he and Kathy Vargas co-curated the exhibition, *American Voices: Latino/Chicano/Hispanic Photography in the U.S.* for FotoFest '94. Buitrón is currently completing an M.F.A. degree at the University of Illinois at Chicago.

B.F.A. (1980) Arizona State University, Tempe

Christina Fernandez (Los Angeles) is a photo-based artist whose work addresses personal, familial and cultural dynamics within a spiritual and historical framework. In 1992, she received a Brody Fellowship for new emerging artists in the visual arts. Fernandez is currently completing an M.F. A. degree at the California Institute for the Arts.

B.A. (1989), University of California, Los Angeles

Harry Gamboa, Jr. (Los Angeles) is a multimedia artist and co-founder of the avant-garde Chicano art group Asco (1972-87). In the past two years, his work has been exhibited at the Robert Flaherty Seminar, New York MOMA, and the 1995 Whitney Biennial. In Fall, 1994, Gamboa had a major solo exhibition of new works in various media (*The Urban Desert*) as part of the Los Angeles city-wide biennial *LAX: The Los Angeles Exhibition.*

Miguel Gandert (Albuquerque) has been documenting Hispanic traditions and lifestyles in Albuquerque and the communities of the Rio Grande Valley for over a decade. He has been featured in a solo exhibition at the Smithsonian's National Museum of American Art (1990) as well as in the 1993 Whitney Biennial. In 1990, he joined the faculty of the department of Communication and Journalism at the University of New Mexico.

M.A. (1983), B.A. (1977), University of New Mexico, Albuquerque

Delilah Montoya (Los Angeles and Albuquerque) incorporates printmaking, painting and drawing techniques into her photography and photographic installations. Since 1994, Montoya has been a visiting professor at the California State University, Los Angeles. The Los Angeles County Museum of Art recently purchased works from her collotype series, *Corazón Sagrado/Sacred Heart.*

M.F.A. (1994), M.A. (1990), B.A. (1984), University of New Mexico, Albuquerque

A.D. (1978), Metropolitan Technical College, Omaha, Nebraska

Kathy Vargas (San Antonio) produces narrative series that are unique within Chicano photography because of their abstract form based on multiple exposure. In addition to her numerous solo exhibitions, Vargas is Director of the Visual Arts Program of the Guadalupe Cultural Arts Center (San Antonio) and a board member of Art Matters, the National Campaign for Freedom of Expression and Arts for Life.

M.F.A. (1984), B.F.A. (1981), University of Texas at Austin.

THE MEXICAN MUSEUM

The Mexican Museum is a member-supported fine arts institution receiving major support from the San Francisco Redevelopment Agency; California Arts Council; The Ford Foundation; Institute of Museum Services; Kapor Foundation; Lila Wallace-Reader's Digest Fund; National Endowment for the Arts; The James Irvine Foundation; AT & T Foundation, Grants for the Arts of the San Francisco Hotel Tax Fund; Dayton Hudson Foundation/Mervyn's; Mayor's Office of Community Development; The Rockefeller Foundation; The San Francisco Foundation; the San Francisco Arts Commission Cultural Equity Endowment; U.S.-Mexico Fund for Culture; Wells Fargo Bank; Bank America Foundation; the Lannan Foundation; Anheuser-Busch Companies; The Gap Foundation; Heller, Ehrman, White & McAuliffe; Pacific Telesis Foundation; ARCO Foundation; Bernard Osher Foundation; Kaiser-Permanente San Francisco; Levi Strauss Foundation; McKesson Foundation; Morla Design, Inc.; McCutchen, Doyle, Brown & Enersen; Pacific Gas & Electric; Robert Gumbiner Foundation for the Arts; The Principal Financial Group; USL Capital; Eastman-Kodak Company; Pacific Bell; RJR Nabisco Foundation; First Nationwide Bank; Irvine & Kathleen Garfield Foundation; Laser Graphics; LEF Foundation; Louis Lurie Foundation; US WEST Citykey.